Women Making H·I·S·T·O·R·Y
Conversations With Fifteen New Yorkers

Edited by Maxine Gold

New York City Commission on the Status of Women

52 Chambers Street—Suite 207, New York, NY 10007
Edward I. Koch　　　　　　　　　　Kay J. Wight
Mayor　　　　　　　　　　　　　　Chairperson

© 1985 by New York City Commission on the Status of Women

No portion of this work may be produced by any means without the express written permission of its author and copyright holder, the NYC Commission on the Status of Women.

Printed in the United States of America

Library of Congress Cataloging in Publication Data
Main entry under title:
Women making history.
1. Women—New York (N.Y.)—Case studies. 2. Women in the professions—New York (N.Y.)—Case studies. 3. Women—New York (N.Y.)—Biography. I. Gold, Maxine.
HQ1439.N6W66 1985 305.4′09747 85-2976

ISBN 0-9610688-1-7

Photo of Beverly Sills © Beth Bergman 1975

Book and cover design by Kent Beaty

Second printing, December 1987

To the memory of Professor Annette K. Baxter, who occupied the Adolph S. and Effie Ochs chair in the Department of History at Barnard College, and whose efforts to include the legacy of women in the annals of American history have been a great inspiration to colleagues and students alike.

Contents

Foreword .. *vii*
Acknowledgments .. *viii*
Introduction ... *ix*
Dorothy Brunson: The Making of an Entrepreneur
 Jacqueline Paris-Chitanvis 1
Ruth Clark: Turning Every 'No' into a 'Yes'
 Marianne Ilaw .. 11
Laura Dean: The Drive To Be Different
 Helen Benedict ... 21
Linda Down: Charting a New Course
 Marianne Ilaw .. 29
Geraldine Ferraro: Making National Political History
 Helen Benedict ... 39
Charlayne Hunter-Gault: Newsmaker, Newsbreaker
 Marianne Ilaw .. 49
Amalya Kearse: A Judge with High Honors
 Roslyn Lacks ... 61
Paule Marshall: Filling Silences with Strong Voices
 Helen Benedict ... 71
Helen Rodriguez-Trias: Mixing Pediatrics with Politics
 Helen Benedict ... 81
Yolanda Sanchez: A New York Activist with a World View
 Jacqueline Paris-Chitanvis 91
Muriel Siebert: Playing the Numbers on Wall Street
 Roslyn Lacks ... 99
Beverly Sills: Undaunted and Undefeated
 Helen Benedict ... 111
Ellen Stewart: Founding Mother of La MaMa
 Jacqueline Paris-Chitanvis 123
Geraldine Stutz: She Minds the Store
 Roslyn Lacks ... 133
Chien-Shiung Wu: A Life of Research
 Jacqueline Paris-Chitanvis 143

Foreword

Women Making History: Conversations with 15 New Yorkers clearly demonstrates what we have known all along—that New York City's women play an extraordinary and vital role in making our City the unique and exciting metropolis that it is. This book of interviews offer an inside look at the dreams and accomplishments of outstanding New York City women who are involved in significant areas of human endeavor, including the arts, medicine, science, business, finance, sports, communications, social service, law and politics. In addition, these women represent the broad diversity of cultures and nationalities which give richness and vitality to City life.

In issuing this publication, the New York City Commission on the Status of Women offers both an important and valuable gift to all New Yorkers. In creating a kind of "living" history for students and the general public alike, the Commission has in turn taken an historic step by being the first to publish a work of this kind.

It is with pride and admiration that I introduce this book to you.

<div style="text-align:right">

Edward I. Koch
Mayor

New York City
March 1985

</div>

Acknowledgments

The New York City Commission on the Status of Women would like to acknowledge the many people who have contributed to the success of this project.

The idea for this book came out of informal meetings, more than a year ago, with Commission members Michelle Jordan, Howard J. Rubenstein and members of the CSW staff. Since that day, many others have given their generous support, financial and professional, to make this publication a reality.

Dr. Marcella Maxwell, who chaired the Commission at the time the project was brought before it for review, inspired us with her characteristic enthusiasm and support. We would also like to thank Marilyn J. Flood, Executive Director of the Commission, for her unswerving guidance and administrative support; Charlotte Frank, Executive Director of the Division of Curriculum and Instruction of the New York City Board of Education, for her invaluable guidance and assurances that we would indeed be providing an important service for the school children of the City; the American Express Foundation, without whose major grant the project would never have been brought to fruition; New York Telephone, Brooklyn Union Gas Co. and the Daily News Foundation for generous financial support; Barbara Gribbin for providing vitally important secretarial services; Michael Valenti for his many helpful editorial suggestions; and the 15 women who gave so freely of their time in order to share their thoughts with potential readers.

Finally, we would like to thank Mayor Edward I. Koch for the unflagging support he has always given to the work of the Commission on the Status of Women.

Introduction

During the course of the Commission on the Status of Women's work in promoting public awareness of Women's History Month, it became apparent—particularly in the case of our work with the City's schools—that very little material was available on contemporary women living and working in New York City. The current volume, *Women Making History: Conversations With 15 New Yorkers*, is intended to fill that need.

To create this book, four professional interviewers were asked to write lively, informative profiles which would allow each woman's distinctive voice to come through as she tells her story. We hope that, as the reader "listens in" on these conversations, she or he will come away with the sense of having participated in an intimate, informal visit with 15 women who have made a unique contribution to New York City life. Especially for younger readers, it is also expected that these profiles will provide tangible examples of how women in the 1980s—known and unknown—are living their lives, how they manage career and family responsibilities, and how they see themselves in relation to the world around them.

While a good number of the women we have written about have attained a measure of well-deserved economic success, it was not our intent to separate out that aspect of their lives from the larger picture—one which portrays women making historic breakthroughs in various areas of human achievement. In addition, we clearly wanted the book to reflect the cultural diversity of the City itself, as well as its multitude of lifestyles and occupations.

Obviously, in a City like New York, which attracts the best and the brightest, the task of selecting only 15 representative women was an extremely difficult one. Informal mention of the book to colleagues and friends invariably evoked great enthusiasm, often followed by a half-joking, "How come I'm not in it?" Without taking away from the individuality of our subjects, in a larger sense those friendly critics—indeed all of us—*are* in the book.

We are there with Geraldine Ferraro as she describes her historic debate with Vice President Bush; on stage with Beverly Sills as, in her state of complete exhaustion, she manages to get through a performance of *The Magic Flute*; crossing the finish line with cerebral palsy victim Linda Down during the New York City Marathon; on location with Charlayne Hunter-Gault on assignment in Grenada; walking angrily beside Muriel Siebert as she is ushered through the kitchen entrance of an all-male private club; sitting on the edge of our seats with author Paule Marshall as she waits endlessly for a manuscript to arrive from a publishing house; infused with the boundless energy of communications entrepeneur Dorothy Brunson, as she works through the night on yet another assignment she could not refuse; spinning on the stage with Laura Dean's dancers as they go through their dizzying paces; and struggling with Ellen Stewart as she works tirelessly to keep the La MaMa Experimental Theatre Club afloat.

Indeed, each of the 15 interviews tells the story of a woman who is prepared to give whatever it takes to realize her particular dream. And while readers may or may not share the same visions, we *all* can share in the inevitable frustrations and joys that accompany profound personal growth and professional accomplishment.

Finally, we expect that this volume might serve as a model for other regions of the country where efforts are being made to highlight the role of women—now and in the past—in the shaping of our history.

<div style="text-align:right">
Kay J. Wight

Chairperson

New York City Commission

on the Status of Women

March 1985
</div>

Dorothy Brunson

Dorothy Brunson:
The Making of an Entrepreneur

Marie Doherty

by Jacqueline Paris-Chitanvis

People set themselves up for disappointments by creating impossible fantasies, false illusions. It's very hard, but in order to be whole you have to reject a lot of what society says you should do. That's why I drive my old beat-up car. I don't want a Mercedes or gold chains hanging around my neck. I fight very hard. I don't care if I wear old beat-up shoes. I care that I have an art collection; I care that my children are on the honor roll. I don't want all those other things. You have to fight to keep your sense of values sane. Otherwise, you begin to think,"I'm nobody unless I have a Cadillac or a Mercedes." I shop on Delancey Street, in thrift shops. I've done that all my life. I never thought I should do otherwise. Not because I'm cheap—I give to many good causes—but you can become warped, and it can encroach on your sense of values.

―――――――――――――――――――――*Dorothy Brunson, 1984*

When Dorothy Brunson was growing up in Harlem during the 1940s, she appeared to be like most of the other children in her neighborhood. She played, fought with her friends, got into mischief and generally enjoyed growing up. But in one respect she was different. She had a secret passion—reading. She would read anything from *Peter Pan* to the Hardy Boys, to Shakespeare. And it was through reading that she came to believe that she—a poor, Black child of the ghetto—could be anything she wanted to be, do anything she wanted to do.

"I read a lot of Black history and there was something so unique about the Black experience that it inspired me," she explains. "My heroine was Mary McLeod Bethune. Just to read her life story was so fascinating. And the more I read it, the more I thought, 'If that can happen [to her], why not to me?'"

And happen it did. Today at 47, Dorothy Brunson is worth millions. She owns several enterprises, including Brunson Communications, three radio stations—in Atlanta, Baltimore and Wilmington, North Carolina—and Citimedia, a company in New York that secures national advertisers for radio. "I never thought about not accomplishing things," she says,"because all my heroes [in books] succeeded."

The older of two daughters, Dorothy was born in Georgia but came to live in New York when she was six months old and her parents moved to Harlem. After her father died when she was a young child, her mother remarried and had three more children—two sons and a daughter. Throughout her years in New York public schools, from P.S. 125 to Junior High School 43 to the High School of Industrial Arts (now Art and Design), young Dorothy was exploring her surroundings and waiting for that one thing she was destined to do.

During her high school years, she thought she had narrowed down her career—she wanted to do something "artsy." To that end, she studied fashion, photography, advertising art, drafting design and similar courses. "That was a fantastic period," she says. "We really got a chance to learn and get involved in all kinds of things in New York."

After high school, Brunson attended Tennessee State University in Nashville for about a year and a half. Her first college experience wasn't very noteworthy, she says, because she spent most of her time "playing tennis, swimming and playing bridge." Deciding that she "really didn't want to do all those things," Brunson returned to New York. "By that time I realized that I had not really focused," she says. "I wanted to do something that was going to make money."

Although she had enjoyed the creative classes she took in high school, there was another side of her that she had been fighting. "A very structured, very disciplined, very exacting kind of a person," she says. "It was that side that I kept running into problems with. I took dance lessons, I took music, I took all the things that I thought would help me pursue an arts career. But I didn't like the unsureness of it. Where would I be next week? Next year? I didn't like the vagabond feeling. So I decided to study something that would be more practical."

She went back to school and studied accounting and finance, taking courses at Pace College and Empire State College in New York. She eventually received a bachelor's degree from Empire State in the late 1960s. Throughout her college years, Brunson worked at a variety of jobs. "One of my jobs was dealing with layouts for newspaper ads," she says. "I was supposed to get the ads, look at them, make sure they were placed properly and make sure we were billed properly. That was really nice, because it was the first time that I was doing something that was a combination of both my high school experience and my college training. It was through that job that I first began to learn a little bit about the media. I began to see that a newspaper was not only about journalism, that there was an advertising side.

"It was from that job in 1962 that I went to radio. At that time Sonderling Broadcasting, which owned several radio stations, was looking for someone to be an assistant comptroller [at WWRL]. They wanted someone Black and they wanted someone whom they could give a title to because they were changing over from a foreign language station to a Black-program format. They wanted someone in management that they could show to the community [to demonstrate] that they were responsive. They had to find someone who knew about accounting and advertising and who at least had some understanding of radio.

"During that time, I was doing a lot of volunteer work in the community—NAACP, Urban League—and someone suggested that I go over for an interview. At first I said 'No, I love my job because I'm involved in advertising, promotions and layouts, and I'm planning budgets. I've found a little niche.' But I went anyway and they offered me the job."

After only three months as the assistant, Brunson was asked to take over as comptroller. She says the promotion came so quickly because she was willing to work harder than anyone else in the department and to tackle any job—whether she knew how to do it or not. As comptroller, she would work even harder.

"I took on project after project after project," she says. "They would say, 'Do you know how to do this?' and I'd say, 'Sure,' and then I'd run out and get a book. I went back to school and took courses—communications, management, everything. I never told anyone that I couldn't do something. I worked weekends, I worked nights. I would go home, and when I knew everyone had left, I'd go back and work until 3 or 4 in the morning because I had to get a project done. I didn't want anyone to know that I didn't know how to do it. After I took over the department, we grew from a station that was doing about $700,000 worth of [advertising] billing to one that was doing close to $5 million. My department originally had five or six people; I took it down to three. I put in a computer system and went to computer school."

During the nine years she was with Sonderling Broadcasting, Brunson continued her career climb. After a year as comptroller, she moved to assistant general manager and then to corporate liaison. In 1971, she left Sonderling to become a partner in a new Madison Avenue advertising agency. The partnership, however, was short-lived and Brunson sold her share of the business. "We couldn't get along," she says with a laugh, "but we're still friends."

For about a year and a half Brunson worked as a consultant in radio and advertising. It was during this time that she also decided to start a family. "By that time I was thirty plus and everyone was saying, 'If you don't have children....' Well, I didn't even get married until I was 26," she says. But by the end of 1972, Brunson had given birth to two sons.

One day that year, she got a call from a friend who asked her if she would be willing to invest in a radio station (WLIB-AM in New York) owned by Inner City Broadcasting. She also was asked if she would pull together a group of investors. "I said fine, I'll do that," she recalls, "but nobody told me that they were on their way to bankruptcy. I got some investors, about eight or nine friends, and we invested about $5,000 or $10,000 each."

But getting the investors didn't help Inner City's finances. Six months after they were in business, the bank holding the start-up loan gave Inner City an ultimatum: pay up the loan or hire a qualified general manager for the radio station. They turned to Brunson, and after much arm-twisting she reluctantly agreed to accept the position. When she took over as general manager, the station was $1 million in debt.

Brunson immediately cut the staff of around 35—she considered it much too inflated—down to eight people. She then gave the remaining employees raises and redesigned their jobs. She also restructured the station, made it more community oriented and set about repaying the bank loan a little at a time. A year later, she approached the bank about another $1 million loan to buy an FM station, WBLS, that she hoped would bring in more money. And even though the initial loan was outstanding, the bank, which liked what she had done so far, approved the additional loan. By the time Brunson left Inner City in 1979, it owned seven radio stations and was valued at close to $50 million.

Despite earning a six-figure salary, Brunson left Inner City because she felt it was time she started using her talents to build her own business. With $3 million in loans, she purchased WEBB, a struggling radio station in Baltimore and poured $250,000 into revitalizing it. Two years later, she purchased WIGO in Atlanta, and was on her way.

Brunson attributes much of her success to being goal-oriented and hard-working—traits, she says, passed on to her by her mother. "My mother is a great believer in the idea that if you trust in the Lord, work hard and do things right, you're going to win," says Brunson. "All of us believed that, and we were always hard-working children. We worked during school and we worked to put ourselves through college. There was never any thought of doing otherwise. You worked at it, you did it long enough and you'd get it. And that's what we did. On that point my mother was steadfast, very steadfast. She always found a way. If we wanted to go to the prom and she didn't have money, she found a way. She would say, 'Don't worry about it.' And that was like saying go. That's the thing that gave us children strength."

Brunson likes to recount the story behind her mother's driver's license to show just how determined she is. "My mother learned to drive when she was about 50 years old," says Brunson. "I remember saying, 'You'll never be able to learn to drive. You're too old.' But she tried anyway. She failed twice, but she went back and she went back. And finally she got her license. Over the years she got better, but she was terrible at first. She was afraid. And to this day, she doesn't drive across bridges, or through tunnels. But she's got that license."

A divorced mother, Brunson hopes that she has instilled that same determination in her sons, Edward, 17, and Daniel, 16. She says she has tried to make them understand how important it is to do your best and work hard, no matter what you do. "Life," she says, "is not going to give you anything, you have to work for it." And while she can afford to give her sons money and material things, she makes them earn their spending money—cutting grass and busing dishes in a catering hall she co-owns.

Despite a work schedule that frequently keeps her on the road, she tries to spend as much quality time as possible with her children. They take trips together, play tennis and generally enjoy each other's company. One family activity that fits in with her traveling is reading. She often reads a book and then gives it to her sons to read while she is away on business. When she returns they get together and discuss it.

When her children were younger, the family was based in New York. They now spend most of each year in Baltimore where Edward and Daniel attend school and live in the family's spacious home. A housekeeper, whom she describes as a second mother, keeps an eye on things whenever Brunson is away on business. The family also owns a brownstone in upper Manhattan and maintains a small apartment/office in midtown. "We're here [in New York] most of the summer and almost all holidays and long weekends," says Brunson. Her sons, she says proudly, love New York almost as much as she does. And that is saying something. Brunson, it seems, has been carrying on an intense love affair with the city for almost 40 years.

"When I was a little girl I took advantage of everything that New York had to offer me without anybody ever saying that I had to, needed to or ought to," says Brunson. "New York was my city. I knew where the museums were, I knew where the library was. There was nothing about it I didn't know. I was very much involved in New York. The theatre, the ballet, all those kinds of things I loved.

"I was one of those who would go and get the ticket that was $2 when Carnegie Hall would be packed because of some famous star. Now I never had heard of most of them, but the thing that would always be intriguing was that I would see a sign that said "Sold Out." I would say to myself, 'God, if this is sold out, it must be somebody really great.' So, I would want to see the show. And it is amazing that I would go up and say that I knew they were sold out, but did they have a ticket that no one had claimed. They would say, 'Stand here. We don't know,' and at 7 or 8 that evening when someone didn't pick up his ticket, they would say, 'OK, here's your ticket.' Now a few times I didn't get in, but I did get to see all kinds of people."

Brunson doesn't have to stand around waiting for an extra ticket anymore, but her love of concerts and the theatre hasn't changed. When she takes time out from her busy schedule to relax, she often comes to New York and "overdoses on theatre." When she lived in New York on a regular basis, she used to unwind and keep fit by jogging and playing tennis every Friday morning at the Midtown Tennis Club. She also went swimming regularly at the 63rd Street YMCA. Now she says she doesn't find as much time or as much motivation to exercise.

"In New York I didn't feel so inhibited. I didn't have to care about being Dorothy Brunson. I could put on my sneakers and my socks, tie my hair back, take off in the wind and I was just another person," she says. "You go anywhere else and it's like your prestige level drops 20 points if they see you in sneakers. If there is anything that I find terrible about being a so-called success it's that once you leave New York you are expected to assume another kind of stance that is not reality."

A warm, unpretentious person, Brunson says reality for her is not designer clothes, fancy cars, or lots of furs and jewelry. And while she does have valuable things, including a collection of Black artists' works, she lives relatively simply for a woman of her means, and is content to drive a 1979 Monarch because it is reliable and serves its purpose. Hard work and the joy that comes from winning seem to mean more to her than the money that comes with them.

Not one to sit back and lord over her businesses, Brunson is involved in the workings of her stations and even sells advertising space for Citimedia. Why? "I like growth," she explains. "I just could not sit back and say, 'Well, I'm successful.' I don't believe there is such a thing."

What keeps her striving to accomplish more, she admits, is the thrill of going out into the business world to do battle, to win one more deal. She loves the feeling, the natural high that comes with accomplishment, with winning. "In order to get that feeling again," she says, "you have to go out and do it again. You win one race and the exhilaration and training make you have to do it again. That's why people don't quit. People in show business have to do one more play, hear the applause one more time. The entrepreneur has got to do the deal again. For the money? Yes. But the victory is getting that feeling of 'I did it!' and then it's over with. The having it is not half as delightful as the getting it."

What's in her future? "I want to get two more radio stations," she says. "And perhaps if I am lucky enough, a TV station, too. I also would like to make the sales arm of my business grow, and then I

want to get into some of the new technology [video, video disks, home entertainment]."

Even though she does not go after money for money's sake, Brunson is one of the first to admit that building a financial base is important, especially for Black Americans. "You can create all the great programs in America—the CETA Program, the anti-poverty program. You can legislate civil rights and do all that," she says, "but economic survival is the thing that will change the structure. With the ballot and the dollar you can have an impact on America. With the ballot you can have some impact but without the dollar, forget it. So when I talk about Black ownership, I'm talking about being in control of the dollar so that *you* can decide how to reinvest it back into your community and into the nation as a whole, so that ultimately you may benefit other Blacks."

Any regrets in her life? "I can't think nonprofit," she says. "I don't think regrets, or sorry. I don't think petty. Yes, I've been disappointed at an incident or for a moment about a lot of things. But I don't internalize and I don't carry it around. I say, 'Hey, you can't do anything about it.' or 'What can you do about it? If you can do anything, change it. If you can't do anything about it, why give yourself ulcers?'"

And how would she like people to remember Dorothy Brunson? "I'd like to be a living testament to people," she says. "You don't live unless you live in the hearts and minds of people."

Ruth Clark

Ruth Clark:
Turning Every 'No' into a 'Yes'

by Marianne Ilaw

> *Mistakes are nothing more than learning experiences. In order to start a business, you just have to be fearless and confident, and everything else will come. No matter how bleak it looks, I just say we will get through it, or we won't. And I have no intentions of going backwards, unless it's a step back to go ten feet ahead. One of the things about success is that you have to understand that sometimes your decisions are going to make someone unhappy. But you can't keep everyone happy and still achieve. You have to assess what you are doing and be comfortable with it, whether it's approved by the world or not. You should hang in for as long as you can survive, follow your own gut reactions and listen to your own heart. Material things are not all that important; you can't take them with you, and if you get sick, there is nothing they can do for you.*
>
> —*Ruth Clark, 1984*

Ruth Clark was born during World War II, when America was emerging from its worst Depression. Her family didn't have much money, so they couldn't afford to buy her the pretty clothes and expensive toys she longed for. But the young Harlem child didn't mind because she had big dreams, and she knew that one day she would earn enough money to buy all the clothes she wanted.

Today, Ruth Clark sits regally in her elegantly decorated office near Fifth Avenue and recalls the years of sacrifice and struggle. Her eyes twinkle with the same intensity as the expensive jewelry that adorns her wrists and fingers. The road to success was difficult, she admits, "but I believe that hard work pays off, and there are no shortcuts."

In 1974, with little more than a dream and $3,000 in cash, 31-year-old Ruth Clark founded Clark Unlimited Personnel (CUP), an employment agency that matches qualified secretarial and clerical workers with firms seeking temporary employees to fill in for vacationing or ill staff members. Clark recalls that 1974 "was the worst year to go into business," because the country was in the middle of a severe recession with skyrocketing unemployment and inflation. For Clark, though, the recession was good news, a building block for her own business.

During a recession, corporations large and small are often forced to trim their expenses by laying off surplus staff; employees cost money, not only in terms of salary, but also in terms of benefits that include paid vacations, health and life insurance, educational scholarships and holiday bonuses.

But even when employees are let go because of budget cutbacks, *someone's* got to do the work. That's where temporary personnel come

in handy. By hiring "temps," business firms can contract for freelance secretaries and clerks to work on a daily or weekly basis. They only hire when they need to supplement their staff, and they don't have to go to the expense of training or paying for employee benefits. Temps like the arrangements, too. They can choose their hours to suit their needs and work days, nights, weekends, or on a part-time basis. Temping affords them an opportunity to spend more time with their families, pursue college or vocational training and explore a variety of industries.

Although Clark never worked as a temp herself, she had hired plenty of them as a supervisor on previous jobs. She noticed that many Black women (some of whom were the sole providers for their families) worked as temporaries, and she believed that by starting her own agency, she would be able to do more than pay lip service to the phrase, "helping your own"; she would be able to help provide Black women and men with jobs. Today, the majority of temporary workers registered with her agency *are* Black and Hispanic, but Ruth quickly points out that anyone who is qualified is welcome to apply for a job through CUP.

Her first year in business was tough. As a Black woman, she says that she was faced with a formidable task: she had to convince banks to lend her start-up money, and she had to persuade large companies to do business with her fledgling agency. During those first months, she often put in 12- and 16-hour days, including Saturdays.

Indeed, she had some hard times in 1974. "Sure I was hungry some days, and I worked without a salary, but there is a price that you pay for everything you do in life." As she struggled to build her credibility, she stubbornly refused to heed warnings from friends and associates who told her that she would never succeed. "If I had listened to other people, I wouldn't be where I am today," she says. "They told me, 'You have no money, you have no expertise.' But I had a vision and I've learned that as long as you believe in what you do, you can climb mountains. I followed my intuition, my own gut reaction."

Because of Clark's drive, ambition and dedication, Clark Unlimited Personnel drew in $350,000 in billings the first year. An impressive figure, but it was eaten up by salaries for temporary employees, Ruth's own staff, and bills, bills, and more bills—for rent, office supplies, telephones and everything else that keeps a business alive.

But Ruth was "on a roll." When she wasn't working at the office, she made the rounds of cocktail parties, banquets and meetings, drumming up business. She's still doing it ten years later. "Sure, I get a little tired of the parties and the dinners," she confesses. "It's not as glamorous as it sounds, but it's all part of the job, and I love what I do."

Clark especially enjoys being the boss. Before she started her agency, she held a number of jobs, including keypunch operator for the City of New York (her first job after high school graduation) and manager of data processing for American Express—a well-paying, secure position that she relinquished to start her own business. In between, there were many other jobs, but as Clark recalls, "Most of the positions I didn't like, and I was usually smarter than my boss. I had my own plans, my own dreams, but I didn't really talk about it, because people would have assumed I was insane." She candidly admits, "I was fired from some of my jobs, because I wouldn't take any mess." She looks around her spacious office decorated with expensive modern furniture, plush carpeting and shimmering mirrored walls and says with a chuckle, "I hope I never get fired again in my life."

That's one thing Ruth Clark definitely doesn't have to worry about. As the first temporary personnel service owned and operated by a Black woman, CUP's billings climb higher and higher every year. In 1983, the company recorded $2 million in sales, with several hundred corporate clients who belong to the Fortune 1,000—the top-ranking companies in the United States. CUP annually places between 1,500 and 2,000 temporaries with its client firms.

CUP has branched out, too. In 1977, Clark incorporated a second firm, Clark Unlimited Placement, which fills corporate requests for full-time, permanent employees. (She proudly points out that every year, one out of five temporary employees moves into a permanent position.) And in 1979, the agency opened up a branch office in Manhattan's financial district.

With such prestigious clients as Chase Manhattan Bank, Avon, General Electric and Freedom National Bank, CUP temporaries surely must deliver quality service. Some days, Ruth receives almost more requests for temps than she can handle.

Referred to as "a very nice lady" by an executive at Chase Manhattan Bank, one of CUP's biggest clients, Clark is also a creative, hard-driving businesswoman who insists on professionalism from her employees as well as the temps and permanent-job applicants. "Yes," she says, "I can be hard-nosed, but I believe I'm a good boss."

Although a number of the CUP temps are young, or inexperienced about the business world, Clark won't permit any unprofessional or sloppy style of dress, hairdo or makeup. She expects applicants to maintain a businesslike appearance, and CUP's rules include no jeans, no exotic hairstyles and no gum-chewing during an interview.

Clark understands that some individuals need to express themselves through creative forms of dress, but she doesn't believe that it has a place in the office. "After all," she points out, "we're dealing with corporate America. If you want to wear an exotic hairdo, fine. But wear a wig when you go out on a job."

Ruth personally believes that a businesswoman does not have to "dress for success" in a severely tailored, masculine-looking business suit to prove that she is a professional. "I don't believe in the suit and the tie around the neck for women," she states flatly. "I do not like that real tailored look. It's your presence, not your clothes, that counts."

She favors softly constructed, feminine clothes and is fond of wearing unique, hand-crafted pieces of jewelry. She laughs and confesses, "When I was a little girl, I always wanted to be glamorous. When I started the business, I didn't think about it. I didn't want to be gorgeous and beautiful, I wanted to see my business succeed." But in 1984, to celebrate the tenth anniversary of Clark Unlimited Personnel, Ruth followed a strict weight-loss diet in order to streamline her figure. Now tall and svelte, she says, "I wanted everything to be together for my tenth anniversary. The business is doing fine, so now I can be gorgeous!"

Ruth always manages to look elegant, even though her working hours sometimes stretch out to midnight. She arrives at the office between 8:30 and 10 in the morning, and attends to the most pressing business at hand: a rush order from a client, urgent telephone messages from business associates, an important staff meeting. Ruth shakes her head and sighs, "It's hectic, brushfires constantly!" In the middle of the day, she often slips away from the office for a business lunch at an exclusive New York City restaurant.

Ruth smiles as she recounts how restaurant hosts are often surprised to learn that "the Clark party" refers to *Ms. Ruth* Clark and not some Mr. Clark. "Sometimes a maitre d' will look at my male guest and say, 'Come this way, Mr. Clark.' And I'll smile and say, 'It's *Ms.* Clark, and that's *me!*' "

After lunch, it is back to the office for more meetings, paperwork and telephone calls. As Clark's business has grown, so has her own personal reputation—she's sought after by many publications wanting to tell her "rags to riches" story. To date, she has been profiled by *Essence, Savvy* and the *Daily News*, among others. Also in demand as a television talk show guest, Clark has appeared on "Midday Live," "Hour Magazine" and "Inside Business Today."

She takes time out of her busy schedule to lecture to women's groups and students and says that she hopes she is able to serve as a

role model and a mentor for other women and young people. "When I was coming up, there were no other Black women in the business world. And that was always my dream; I wanted to make it in the business world—not fashion, not theatrics, not beauty culture."

But Clark stresses that she is a "rare case. I didn't like school. Education doesn't necessarily prove that you are intelligent. I'm more intelligent than some people with Ph.D.'s—my education has been learning from other people."

However, her advice to students is straightforward: "You should go to college, definitely. I'm not saying that it's impossible to make it without a degree, but it's very competitive today. Go to college, but always keep your dream, your agenda, in the forefront."

A self-made businesswoman, Clark does believe in helping others. She volunteers her time to such organizations as the March of Dimes, Edwin Gould Services for Children and the Edges Group. Her professional memberships include Women Business Owners of New York, the Women's Forum, the National Association of Temporary Services and the National Minority Business Council.

But success hasn't gone to her head. She still maintains that she is as down to earth today as she was when she was still struggling. "I don't carry a chip on my shoulder because of my success, and I don't get carried away with it either. My story lets women know that there is hope for them, that there are opportunities out there. The odds were all against me, but I knew I was going to achieve. I was always most concerned about keeping my head together, my feet firmly on the ground and not forgetting where I came from."

It is unlikely that she will ever forget her Harlem roots. Growing up in a close-knit family with her brother, father and stepmother, Ruth says that she was always encouraged to strive for excellence. "My stepmother and father were very strict," she says. "I hope they are looking down on me from heaven and are proud of what I've done."

Her family always will be important to her. Although she has no children of her own (she is divorced), she explains that her relationship with her nieces and nephews is very close. She even hires them to work part-time at her office, where they are able to learn the ins and outs of the business. "I believe in helping my family," she says firmly.

She frankly admits that if she did have children, her business might not have been so successful. "This is not a nine-to-five job. You must eat, sleep and literally live your work." She strongly believes that children suffer emotionally when their mothers spend long

hours at the office. "If I had children, I don't know if they would have been happy. A business is never on its own. And it becomes more demanding as it grows; it demands more of your attention. As kids grow up, they need less attention, but a business can never take care of itself."

Ruth laughs at the popular "Superwoman" concept—the belief that a woman can work 12 hours a day, raise young children and keep her husband happy simultaneously. "I don't believe in the Superwoman syndrome," she says emphatically. "It's very dangerous for us to fall into that myth. In the past, there was always someone to clean the house and take care of the kids; that's why men have done well in business, but it's difficult for a woman to work and have a family."

Ruth is happy to see more women in the work force, but she cautions that not every woman—or every man—is capable of running a business. "Female bosses are becoming a way of life," she observes, "but everyone does not have the ability to be her own boss. Many working women want to be in business for themselves, but not everyone is equipped to do it. Business is not all glamorous; you've got to take a lot of knocks. As a woman, it has been hard for me—I've experienced difficulties getting clients, getting bank loans, getting people to believe in me. But I believe in turning every negative into a positive, turning every 'no' into a 'yes.' You don't need money to run a business, you've just got to be fearless and confident. I have no fears; when I started, I knew nothing about business. Sure, I've made mistakes, but they were learning mistakes and I have no intention of going backwards."

Although she's a world-class achiever, Clark reveals that she has been inspired by the work and the courage of several prominent Black women, including Mary McLeod Bethune, the late civil rights activist; Dorothy Height, president of the National Council of Negro Women; Rose Morgan, owner of a well-established beauty salon in Harlem; and Dr. Betty Shabazz, widow of the slain Black civil rights leader Malcolm X.

Clark believes that New York City offers unlimited career opportunities for women—"*if* they're willing to work hard. New York is the roughest place to succeed, and as far as I'm concerned, it's the only city in the country.

"I love New York!" she exclaims. "I made this city work for me; I turned it around." She also loves the cultural and social flavor of the city. In her leisure time, she enjoys dancing, dining out and attending art exhibits and the theatre. But some of her happiest moments are spent in her spacious co-op apartment on Manhattan's upper East Side.

When she can get away from the office, Clark enjoys traveling to different countries and meeting people from other cultures. "But you know," she points out, "when I visit other places, I realize how fortunate we are to be Americans."

Perhaps what she realizes is that in poor, developing nations or even in more sophisticated, more developed countries, a woman wouldn't have too great a chance to head a successful business.

Ruth Clark reflects on her own achievements for a moment, and before she turns her attention to the flashing lights on her office telephone that demand her response, she says, "If you want to go into business for yourself, you should hang on as long as you can survive. And that goes for anything. Follow your own heart and mind and don't give up your dreams. All it takes is the 'two C's'—courage and confidence."

Laura Dean

Laura Dean:
The Drive To Be Different

by Helen Benedict

Everybody comes to New York to work, but since I'm a native New Yorker, I had to leave. So, in 1968, I went to San Francisco for two years and got myself a job working nights at the Bank of America. During the days I worked at a dance studio.

I locked myself up in that studio because I wanted to create something original. I wanted to do something I was doing, not someting I'd been taught. I started pacing the room and I found myself pacing in circles. If you lean your body in as you walk in circles, you walk smaller and smaller circles like a spiral, and I ended up doing something I'm known for now—spinning. That was a real breakthrough for me, because I was physically doing something that was uniquely me. I hadn't experienced it before in any dance class or anyplace... I was experiencing things I'd loved as a child—children love to spin, the sensation of it. And that's what dancing should be: sensation.

—Laura Dean, 1984

Laura Dean loves to talk, which is unusual for someone who calls herself nonverbal. She can discourse on anything from art to abortion to Einstein. Yet she is never as articulate as she is in her work, creating the music and choreography of the Laura Dean Dancers and Musicians. That is where her true originality, the originality she strove so hard to find, really shows.

Dean's work has already made its mark on the world of dance. She has won several awards, including two Guggenheim Fellowships, and even though she is only in her late thirties (she won't reveal her exact age), she is famous way beyond New York. In Japan, for instance, her troupe receives standing ovations. Critics in England, Europe and all over the United States wax lyrical over her rhythmic, hypnotic dances, even while struggling futilely to interpret them.

"All kinds of crazy things have been said of me," she muses in her soft, lilting voice. "That I'm influenced by Sufi dervishes, Zen Buddhism...but none of that is true. There's only one critic who's ever got close to what I'm doing, and that's Allan Ulrich in San Francisco. Otherwise, I don't understand what the writers are saying about my work, I really don't. And that's making me want to write about what I do myself."

Her work stuns people because it is powerful, insistent and moving. She likes to use her dancers as instruments of music and rhythm, not only of movement. They stamp their feet in patterns that sometimes sound like a forest of well-orchestrated drums; they raise their voices to sing in flowing harmonies; and they spin, spin, spin all over the stage like colorful, whirling tops. The rhythm catches you up and mesmerizes you, at the same time preventing you from getting bored or sleepy

by abrupt changes of tone, speed and emotion. Sometimes the dances make you jump, literally startled out of your seat. Other times they cause a rush of emotion, sending goose bumps prickling all over your skin. Is Dean aiming for this sort of effect, or is there some other kind of message she wants to send to her audiences?

"I just want my work to move people," she replies simply. "And maybe uplift them a little, too. That's about it."

Dean herself is almost as dramatic as her dances, although quietly so. She is extremely beautiful in a soft, understated way—light skin that even in hot weather appears to be dusted by a fine, white powder; even features; a wide, sensual mouth; and a delicate sprinkling of freckles. She moves langorously, frequently running her fingers through her hair. And she dresses fashionably—black, billowing pants with startlingly flashy red sandals, or a bright green dress, hitched up around her hips. Yet all of this is subtle, gracefully subdued—she could never be called flamboyant.

Dean's drive to be different started long before the day she first locked herself up in that San Francisco studio, forcing herself to break away from the training she'd received as a dancer for modern dance choreographers Paul Taylor and Merce Cunningham. It began when she was a child, growing up with artistic ambitions in a bland, middle-class community on Staten Island where, as she put it, "if you weren't into American Bandstand and how to curl your hair, you were definitely on the outside." Her obsession was to become a dancer.

"I was born a dancer," she says emphatically. "I always had a fascination with movement. I remember in kindergarten getting up and doing a little dance about falling asleep. So it was always there. And also I was a very nonverbal child, so I was always expressing things through movement.

"So I became this strange person who went off immediately after school and took a dance class, instead of hanging around with friends. I'd leave Staten Island at 3 in the afternoon and come back at 9 at night, and I was only 10 or 11 years old."

Her family wasn't at all artistic, and her ambition took them by surprise. True, her mother took her to see such modern dancers as Martha Graham and paid for her dance classes, but not with anything but a proper education in mind.

"Yet, even though they weren't artists, their professions were related to what I do," Dean says. "My father was an architect, which is the composing of space—and that's what choreography is, too. My mother is a mathematician, and music is really a form of math."

When Dean was about 11, she further surprised her family by insisting on going to the School of American Ballet just when they were about to move overseas for the summer, where Dean's father had a temporary job. She auditioned for the school, got in against great competition ("I knew basically nothing of ballet, but I had such a love of it!") and persuaded her mother to pay for her tuition with the money that would have been spent on her plane ticket. Her mother went to join Dean's father, taking Dean's brother and sister with her, while she was left behind to live with neighbors. She was already independent and dedicated enough not only willingly to relinquish her family for career interests, but to enjoy doing so.

"I took three classes a day, and I loved it," she says now with a smile, "and I'm incredibly grateful for that training."

After two years at the ballet school, she was admitted into the High School of Performing Arts in Manhattan, from which she was eventually graduated with top honors in dance and music.

"By my senior year, I think my family finally became aware that I was serious about a career in dance and, interestingly enough, I lost their support. They didn't want to see me 'get hurt.' I'm sure it was out of loving [concern] rather than just sheer negativity; I actually didn't start getting support from my mother—my dad passed away quite a while ago—till just a couple of years ago when Clive Barnes called me a genius." Dean smiles, half proud, half self-mocking. "Then she was finally convinced!"

"But it's interesting," she goes on. "If you really feel something, no matter what your family says, you can do it. Very often I hear someone say, 'I couldn't do it because my family didn't support me.' So what? So you go out and get your own job. I started making my own living when I was 16. So what if your family doesn't support you and fights the idea? By the age of 16 or 17, if someone has a belief in what he or she is doing, the person should go ahead and do it!" Dean winds down and muses again, her brow furrowing as she looks off into space.

"I was lucky I had that belief, though," she adds finally. "A lot of people don't know what they're going to do. Then they turn around at age 40, and it's too late."

Perhaps it was Dean's ability to go against the tide, her resilience in the face of the doubts of her family that made her able to forge ahead with her vision. For, even though nowadays she tends to be well received by reviewers, there was a time when people booed her performances, something that still makes her angry.

"I don't think audiences should ever boo and hiss. If they don't like something, they should leave," she said firmly. "It's very cruel to the

performers. At a political rally, that's fine. If they're coming to see something that's new, they have to take their chances. They have to come with an open mind. It's highly irresponsible to act like that. But I haven't had too much of that happen. I did earlier on, but what's happened now is not that I've changed but that people's perceptions have changed."

Dean isn't timid about exposing her personal concerns, her irritations and worries. She eases into intimacy quickly, loving to talk about the dilemmas of being a single professional woman who wants marriage and babies, about people's love lives and family lives, and despite all she has to do, she seems permanently unhurried. But at work—rehearsing her dancers, for instance—she becomes quite different. Then her drive, the authority and presence of mind that make her a leader, not a follower, are very apparent. She watches her dancers carefully, taking note of every little missed beat or hand bent at a wrong angle, and afterwards, kindly but firmly, she corrects them. "People!" she calls to get their attention, "we've got to work on the spinning because that was..." and she pulls a disgusted face. Her dancers respect her, speaking of her with affection and a touch of reverence when she is out of the room. Yet, for all this, Dean says that she finds working with dancers one of the hardest parts of her art.

"I'm envious of writers and painters because they're just with themselves. Even though they complain, 'I'm so lonely, I want to work with people!' I say, 'Oh, no you don't!' Believe me. It's difficult enough as it is trying to be creative, but then you have to deal with different personalities on top of it, and sometimes those personalities can be unpleasant.

"In one group I had [Dean's troupe consists of six dancers and two musicians], there was one extremely negative person who made a lot of the other dancers also very negative. No one was being truthful with me. A couple of weeks ago I received a very long, extremely apologetic letter from one of those dancers. It was nice, but just a little late. The present lot is a nice group of people, but there are always changes and difficulties.

"I'm a very internalized being, so it's not easy for me to deal with all these personalities. But I'm not a writer or painter, so I have to."

Working in an art form that is so labor-intensive means that Dean can reap little financial benefit from her success. The company is in constant financial trouble and depends for income on hard-won tour engagements, grants and other outside funding. Every penny must go into renting the loft they use as a studio, costumes for the dancers, equipment, publicity and salaries. The impecunious state of the company is evident in its surroundings. Their loft, located on West 17th

Street in Manhattan in an industrial area between Fifth and Sixth Avenues, is undecorated and shabby. Paint peels off the walls and ceilings, the floors are smooth but far from highly polished, and the whole area is dimly lit and poorly ventilated; on hot summer days, the dancers visibly suffer as they rehearse. Dean sits in her dingy office at a huge desk, surrounded by racks of dancers' clothes, clusters of shoes, a video machine and bare bookshelves, and talks about her dashed hopes for a new studio in Brooklyn.

"We were going to move into a huge loft there with lots of light—it was also nice and cheap—when we found out there was exposed asbestos in it." She looks saddened and angry, then returns to the subject of money.

"It's really a very strange art form. A piece of choreography is not an investment like a painting. You can't pick it up, keep it, sell it, watch it increase in value. Music is not quite so strange because there are scores that you can get published. But choreography is not a product."

Dean's financial troubles have been the biggest burden of her career. Four years ago, they even caused her to give up dancing, for her previous management had made such a mess of the company's finances that she had to take over herself. She regrets this now, and is working hard at getting herself back into shape so that she can once more dance in her own troupe.

"Four years is a long time not to dance," she says sadly.

To get herself back into dancing shape, she devotes every morning to working out. She rises at 7, gets to her health club by 8 and spends the next four hours doing ballet, barre and floor exercises and using the Nautilus machines. She's planning to add swimming and karate to her work-out regime. Once she gets to the office at noon, she devotes the rest of her day to paperwork and rehearsing her dancers. If there is a rehearsal of the musicians in the evening, she won't get home until 10. She usually reads then—her favorite hobby—before going to sleep at 11 or 12. On tour, life is even more hectic.

"I make my living by touring, and being on the road eight months a year affects your life, your personal relationships and your friendships," she says seriously. "That's something people don't think about when they go to the theatre and see those people up on stage. Everybody thinks it's such a wonderful, romantic, glorious life. If only they knew!"

Another major responsibility of Dean's is to audition dancers, something that can be very time-consuming. "I have hundreds coming, and I'm lucky if I get one," she says. "Part of the reason for this is

that there are a lot of people now who call themselves dancers, but they're not trained. They take a few dance classes and call themselves dancers! You have to have eight to ten years of training, at least."

This is especially true for Dean's dancers because her work is exceptionally strenuous to perform. Not only do they have to learn to spin without spotting, which means letting their heads follow their bodies when they turn instead of keeping their eyes on one spot, which takes grueling practice (if they don't practice, they'd get dizzy and fall), but they have to be able to dance for up to 30 minutes nonstop. Most choreographers allow the dancers to dance for a few minutes and then exit in order to recuperate before coming on again.

When Dean isn't working out or performing one of her many duties as director of her company, she is composing. She writes all her own music for the dances she choreographs, and recently she has also been creating dances for the Joffrey Ballet and John Curry's ice dances at the Metropolitan Opera. She'd like to do more composing of orchestral works, but says that being a woman puts her at a distinct disadvantage for that.

"Think of a woman composer," she says challengingly. "They're nonexistent! No, I don't want to say nonexistent—there are some wonderful woman composers, but they're never played, never, ever. If you use your voice and you compose, that's a little more acceptable, but if you write orchestral works—just not accepted. The music world is very, very closed to the concept that women can write music."

When she composes a piece of music, or creates a dance, does she do first one, then the other?

"No, music and dance, the one common denominator they have is rhythm. And timing, which is different from rhythm. So when I'm thinking of one thing, the other thing automatically starts to happen. It can be that I'm writing some music first and the dance begins to happen or vice versa. Which is kind of unusual, because most choreographers take a piece of written music by another composer and listen to it over and over again and then that becomes the structure of their choreography. I'm very lucky—I can tailor-make the music for the dance and the dance for the music!" Dean leans back in her chair for a moment, and piles all her hair on top of her head, in a gesture that is quietly triumphant. How much of herself does she put in those dances and that music? She barely pauses before answering.

"Oh, it's definitely me out there," she says bluntly. "I can't be separated from my work. I *am* it!"

Linda Down

Linda Down:
Charting A New Course

by Marianne Ilaw

I am a wounded bird.
 Condemned to walk the earth
 In punishment for some grave, unknown sin.
 Had I once flown too close to the sun?

Where once were wings, strange limbs appeared
 With arms and hands and fingers.
 Useless appendages that could not lift me from the ground
 Heavy with sadness at the memory of flight—
 Earthbound.

Yet, there still remains
 Beneath this soft, white flesh
 The frantic, fluttering, unrelenting heart
 Of a humming bird.

—Earthbound, *Linda Down, 1982*

October 24, 1982 was a very special day for Linda Down. On that crisp fall Sunday, she joined 14,000 other runners—old and young, male and female, professional and amateur—as they charged through the streets of the city in the grueling 26.2-mile race that is known as the New York City Marathon.

Since 1970, the annual event has drawn runners from all over the United States and other parts of the world. And year after year, clad in shorts, jogging suits, T-shirts, and thick, rubber-soled running shoes, they race through the five boroughs of New York City, whizzing past elegant East Side boutiques, dashing by smog-shrouded clusters of factories in Queens, and modestly acknowledging the cheers of the crowds lining the streets of Spanish Harlem.

On that day in 1982, one young woman stood out among the thousands of nimble runners. She was Linda Down, a 26-year-old cerebral palsy victim. Using sturdy steel crutches for support, Linda slowly made her way along the marathon course, miles behind the great mass of runners.

As the race progressed, many of the runners—men and women who had trained for the arduous contest for months—collapsed or dropped out; their bodies simply couldn't take the brutal punishment.

And through it all, Linda Down trudged along, determined to make it to the finish line in Central Park, even if it took all day.

And it did.

Eleven hours and 54 seconds after the race began, Down crossed the finish line, leaning on her crutches, exhausted by the effort. A

remarkable feat for a woman who grew up unable to run, skip, hop or jump with her young playmates.

Identical twins Linda and Laura Down were born in Brooklyn on November 17, 1956. They had more than their looks in common: both were afflicted with cerebral palsy, a condition that occurs at birth when the oxygen flow from the mother to the fetus is interrupted. A variety of symptoms, including paralysis, incoordination, impaired motor function, learning difficulties, and sensory defects are associated with the condition.

Down's specific condition is described as ataxia and mild spasticity, or lack of balance and tightening of muscles, causing a stiff, jerky walk. The Down twins spent their pre-teen years in double-leg braces, and between the ages of 11 and 13 they underwent a series of hip and knee operations to help them walk with greater ease.

How did Down survive the inevitable ridicule and cruel taunts from the other children with whom she and her sister grew up in the small upstate New York town of Milford? "I knew I was 'different,'" Down recalls, "but that didn't stop me from trying to do what the other kids did. And my parents *didn't want* me to receive any special treatment because of my handicap. It was instilled in us to do as much as we could. If there were stairs, we climbed them. If we fell down, we got up. Just like any other child—we had the normal bumps and bruises.

"Children just weren't accustomed to seeing disabled people. It's a difficult thing to deal with, especially for younger children. But they don't realize that it isn't your fault, that it just happened." Down, who admits to being the more outgoing of the two sisters says, "I was always trying new things, and exploring. I was always going into the deep part of the pool—and I couldn't swim." With a mischievous gleam in her eye, she adds, "I played softball—very badly—but I played it. I didn't think in terms of 'I shouldn't do this or I shouldn't do that' because of my disability."

She developed innovative ways to participate in activities where it was necessary to use one's feet or legs. "I could never sew," she says, "because my feet couldn't control the foot pedal on the sewing machine. So instead I would put the pedal on top of the machine and use my hands." But there were times, says Down, when she succumbed to bouts of self-pity: "When we were ten, we went to a camp for the physically disabled. It was kind of a lonely period. Without Laura, I would have felt that I was the only one in the world who had this."

Something else happened when she was ten that really shook her. Her parents separated, leaving only their mother to care for the two

small girls who needed constant medical supervision and physical therapy. Within two years, the Downs were divorced.

"It was a painful time for everyone," Linda remembers. "At first, I felt guilty. I thought, 'If only I had cleaned up my room, or if Laura and I hadn't fought, maybe this would not have happened. And then I thought it happened because of our physical condition.

"It was hard to adjust to Mom going out on dates. After you divorce, I guess it's almost like going through adolescence again. In a sense, we were all going through adolescence at the same time."

Linda describes her teenage years as "a difficult time. It's awkward for everybody, and someone who is physically disabled goes through the same things, only it's harder. Sometimes people are afraid of you. Perhaps they realize that disability is something that potentially could happen to anyone—that's what makes it so scary."

Down says that being a woman with a disability is difficult in a society where "physical perfection is considered synonymous with physical beauty." Although Linda had—and still has—a pretty face, long shiny hair, and a nice figure, she was unable to dance, participate in gym class and do many of the things that teenagers like to do. Her social life was certainly less than ideal.

She recalls the times during high school years when friends tried to set her up with teenage boys who also were physically disabled. "One time a girl friend introduced me to a guy who was handicapped, and said, thinking of Laura, 'too bad his brother isn't disabled.'"

Most people don't realize that having a physical disability doesn't mean that a person isn't normal. Linda's dreams and hopes are the same as those of any non-disabled person. And she has a good shot at achieving those goals, because she's extremely ambitious, intelligent, and outgoing.

Education and learning have always been important to her. She says, "When I was a teenager, I didn't really focus on my body. I really loved school, I loved learning things and reading. My mother always stressed education, and I believe that disabled persons should get as much education as possible so that they can have more options. I couldn't be a waitress, because I can't hold a tray ... I never really had a specific career goal in mind; I went through phases. I was very interested in biology, and I toyed with the idea of nursing. But then I realized that I couldn't do certain tasks. Just from my experience of being in hospitals, I knew what nurses had to do."

Down realized that she wanted a career that would enable her to help others. She enrolled in Pace University in Pleasantville, New

York, and selected psychology as her major course of study. Her good grades and dedication to her work paid off: in 1978 she graduated magna cum laude and was voted into membership of *Who's Who Among Students in American Colleges and Universities.*

But Down knew that she needed more than an undergraduate degree in liberal arts to pursue her career goals, so she applied for admission to Adelphi University's Graduate School of Social Work. While she worked on her master's degree at Adelphi, she accepted a position there as a graduate research assistant. In 1981, she received her MSW, and shortly thereafter, her professional certification by the State of New York.

Down went to work as a tutor for the Institute for Rehabilitation Medicine in Manhattan, where she taught basic reading, writing and math skills to disabled children. She later moved to The New School for Social Research, where she took a position as a research associate, helping to conduct studies on mentally retarded and emotionally disturbed children.

With solid work experience behind her, in 1982 Down decided to branch out on her own as a writer, lecturer, and fund-raiser, promoting issues of concern to the disabled. She traveled around the country, appearing on radio and television programs and delivering speeches to help raise funds for United Cerebral Palsy, a nonprofit organization that offers guidance, training and support to individuals with Down's condition.

In 1983, Adelphi University offered Down a position as coordinator of services to disabled students, faculty and staff. Today, she thrives on the challenges of the job. Her day begins at 8 A.M., when she leaves her sunny Park Avenue studio apartment and grabs a taxi to Penn Station. There she boards the Long Island Rail Road train that takes her to Adelphi in Nassau County. She enjoys the commute, she says, "because it gives me time to read a newspaper and sip a Diet Coke."

When she arrives at the office at 9:30 A.M., she immediately catches up on paperwork, reviews her mail and checks her telephone messages. She says, "I spend so much time on the telephone, it practically has to be surgically removed at the end of the day!" As the liaison between disabled students and the university, Linda provides many supportive services to the handicapped on campus. "Accessibility [barrier-free routes that enable students using wheelchairs to travel around the campus unassisted] is a big problem at Adelphi, which I'm slowly trying to solve," she says.

She spends a good part of her day counseling students; they're able to relate to her, she believes, because she has shared their

experiences. But she's no soft touch: "I try to be fair in the way I treat students," she says. "I let them know what I expect. I don't try to do everything for them; I want to try to help them do as much as they can themselves.

"I don't think of myself as a dependent person," she says firmly. "It's very normal and natural to feel sorry for yourself, but it can become very destructive if it's not put into proper perspective." Down tries to instill in her students that same sense of confidence and independence.

Although she finds her job challenging and satisfying, she also makes maximum use of her free time. When she's in the mood, she'll whip up a special dish for guests or for her sister Laura, with whom she shares her cheerful apartment. She also is an avid reader, and is working hard to build a free-lance writing career. A member of the Writer's Guild, Linda has worked as a copywriter for Channel 13, and is now developing a screenplay. Her articles have appeared in a variety of sports publications, and even her poetry has received "pretty good feedback."

She also finds time to volunteer to speak before groups of disabled youngsters. But she points out that, "I never come in with a pre-packaged speech. I like to discuss children's career goals, and I stress that it's important to let other people know what you want, to keep a career goal in mind and have the courage to let others know; it's better than keeping quiet."

While she serves as an excellent role model—for disabled and non-disabled children alike—she doesn't believe that mimicking someone else's character traits is a sure path to success. "I didn't have a mentor," she states. "There's no one that I really modeled myself after. But my mother was the biggest influence on my life."

Linda adds that she's happy to see so many women achievers today—politicians, athletes, astronauts and scientists. There were few female role models when Down was growing up. She recalls an incident in her third-grade class: during a history lesson, a boy turned toward her and asked, "Aren't you sorry that you're a girl? All of the famous people in history are men!" Linda quickly retorted, "That's not true!" But when the boy demanded that she name one famous woman in history, she recalls, "I named the Statue of Liberty; it was all I could think of!"

Would she like someday to be described as a "famous woman in history"? She shakes her head emphatically. "No, I don't think that I want to be a famous this or that; I would like to feel that when my life is over that I was a woman of substance who took risks and dared to stand up for what she believed in."

As the first woman on crutches to participate in the New York City Marathon, Linda admits that she was "very scared" before the race. But she had experienced similar doubts before she ran in the 1982 L'Eggs Mini-Marathon. She reminisces, "My biggest fear was that people were going to laugh at me because I was on crutches. I thought, 'So what? The worst that can happen is that I'll be laughed at. I won't die.' You're not afraid then."

She pauses thoughtfully for a second and then says, "We all tend to disable ourselves. We say, 'I can't do it, I'm not pretty enough, I'm not smart enough.' We all have our own disabilities. The marathon was very frightening; I was a basket case a few days before it took place. I was scared to death.

"But the marathon intrigued me. I saw it as a challenge, like anyone else would. It's a way to stretch your abilities and test them out. Running the L'Eggs Marathon showed me that I could do six miles without dropping dead." Down trained for the 1982 marathon for five-and-a-half months, running, exercising and learning how to cope with her physical limitations. She has since run two more marathons, in 1983 and 1984, decreasing her finish time by about three hours.

"I didn't set out to be courageous," she explains modestly. "I knew all of my failures. But I wanted to be part of something that was international, and I thought that it might be positive for people to see that you *can* do things that might seem impossible. I'm never going to win prizes for my time, I'm not world class...I was still in Brooklyn—about nine hours behind—when Alberto Salazar won the race." She confesses that she reached a point where she wanted to quit; during the twenty-third mile she didn't think that she could possibly continue. But despite the pain in her hips and her intense fatigue, she was determined to reach the finish line. In her mind she repeated over and over again, "I'm so close now. I'm so close now." She had three miles left to go. She says, "Once you put in a certain number of miles, you've just got to go on."

She laughs and recalls how one of the newscasters covering the event described her as "driven." "I thought, 'If I were a man you wouldn't describe me as driven.' Being athletic has only recently become acceptable for women."

Because of her condition and her determination, Down's participation in the marathon drew national attention, and she received recognition beyond her wildest dreams. She became a "media star," the subject of newspaper articles and radio and television reports. She was later named "Athlete of the Year" by United Cerebral Palsy, and was invited to the White House, where President Reagan com-

mended her for her accomplishments. NBC-TV named her "Sports Personality of the Year," and she appeared on a cable television broadcast entitled "Sports Women of the Year."

Down was a little embarrassed by all the sudden attention. "People were very nice to me and very supportive. It was exciting, but at the same time, it was a difficult period for me. I was somewhat self-conscious, and I certainly didn't expect to go to the White House. Suddenly I was a hero, and I was afraid I wasn't going to be what everyone wanted me to be. But you can't feel that you have to match everyone's expectations."

Although she was a bit uncomfortable with all of the public exposure, in time the excitement faded and her life returned to normal. After all, Down lives in New York City, where heroes and stars are born every day.

She enjoys being able to live a private life in a city that is so large and diverse. Because of her condition, she says, "I feel comfortable with people who are different in any way. I'm not as frightened by it as others may be. There tends to be a little more tolerance of differences here in New York. My crutches don't raise any eyebrows, which is a healthy thing. Yet New Yorkers are much more supportive than they get credit for. If I ever needed any help, I got it. I once fell into a grating, and I was lying near the gutter with my crutch nearby. Someone helped me to my feet and dusted me off.

"But you really do have to be independent to live in this city," Down continues. "You can't feel that you're going to come to New York and people are going to help you with everything. You can, however, locate pockets of support."

Linda reminisces about her early days in Manhattan: "When I first came here, I kept getting lost. I was in awe at first—as is everyone. But New York is so intriguing, and it has so much to offer! Now I feel like Central Park is my second home."

Down strongly believes that professional, educational and social opportunities for women are greater in New York City than in a small town or community. But she points out that, "It's hard to be a woman anywhere...it's hard being a man...it's hard just being a human being. You just have to be the best you can be. You've got to think in terms of what you want to do with your life and go after it. But if you are looking for a career in the theatre, the arts or the corporate world, New York City is the place to be. It's hard to attain success in these areas in a small town in the middle of Iowa."

In addition to expanding her talents as a writer and building her credentials as a social worker, Down would like to get married some

day, and adopt a child or two. She muses, "It would be nice to marry someone with children. Physiologically, I can have children, but it wouldn't be fair to the child. I can't predict when I might fall. And I can't expect others to care for my babies."

If there is one piece of advice that Linda would pass along to her children—or any child—it is this: "Don't be afraid to take risks. It's very easy to follow a pattern, but it's not easy to make your own way. Being like someone else doesn't make it easier; no matter where you go, you carry *yourself* with you."

She smiles gently and says, "I never thought in terms of being just like anybody, and I wouldn't want anyone to get up and say, 'I want to be just like Linda Down.'—It's already been done."

Geraldine Ferraro

Geraldine Ferraro:
Making National Political History

The New York Times

by Helen Benedict

> *Tonight, the daughter of a woman whose highest goal was a future for her children talks to our nation's oldest party about a future for us all.*
>
> *Tonight, the daughter of working Americans tells all Americans that the future is within our reach—if we're willing to reach for it.*
>
> *Tonight, the daughter of an immigrant from Italy has been chosen to run for vice-president in the new land my father came to love...*
>
> *"By choosing a woman to run for our nation's second highest office, you send a powerful signal to all Americans. There are no doors we cannot unlock. We will place no limit on achievement.*
>
> *If we can do this, we can do anything.*
>
> ————————————————*Rep. Geraldine A. Ferraro, 1984*
>
> [*on accepting the vice-presidential nomination at the Democratic national convention, as reported by the New York Times (July 20, 1984)*]

It is easy to get sentimental about Geraldine Ferraro. A housewife/teacher/lawyer from Queens, she rose to take the most important political place in this country a woman has ever had—candidate for vice-president of the United States on the ticket of a major political party. She not only accomplished this extraordinary feat at 48, still young enough to have a daughter in high school, she did it with charm. She stirred the emotions and loyalty of people throughout the country with her speeches during the 1984 presidential campaign, won the hearts of an oversensitive and critical press (who wanted so badly not to seem to favor her that they were extra harsh) and impressed millions of television viewers with her stately but not unfeminine cool. Journalists all over the country waxed lyrical about her "immense green eyes," her "mind of a heavyweight," her devotion as a wife and her skill as a politician. Even feminists like Gloria Steinem, who once might have objected to Ferraro's Mom and Apple Pie image, celebrated her femininity:

"... She is one of the few women with 'masculine' power who has not sacrificed her sensuality. In everything from dress (she has rejected male-invented 'dress-for-success' suits) to values (she is quite comfortable speaking from her experience as a woman and a mother), Ferraro is a remarkably whole person." Ferraro has thus been lauded because she stands for the dreams of more than half the American people. She has proved that women can do it, too. History will not forget her.

But aside from all this flowery praise, what is Geraldine Ferraro *really* like? She has been profiled by top journalists in just about all

the major newspapers and magazines in the country, yet what Ferraro seems to be like depends a lot on who is describing her, friends or enemies. This is true for any politician, but even more so for a woman. From her enemies' point of view, she can't win no matter what she does. If she acts like a good politician—tough, smart and serious—she's condemned for not being a traditionally soft and feminine woman. But if she behaves like such a woman—giggles or is quiet or sweet—she's condemned as a giddy dame who doesn't belong in politics. She has even been attacked for ignoring her children out of personal ambition (has anyone ever said that of a Kennedy or Reagan?). As Bill Reel, a columnist for the *Daily News* wrote, "Progressives praise her plucky pioneering spirit for shedding the Queens housewife-and-mother mold to achieve bigger and better things, but I'm holding my applause. I don't think there is a bigger and better thing than motherhood. Kids before career, I say. Family before feminism." Even people supposedly on her side have insulted her for being a woman. John Seiberling, for instance, a Democrat of Ohio, introduced her at a rally as, "a woman, but one of intellect..." For those who believe the old sexist adage that women are featherheads who belong in the kitchen, Ferraro could never have won.

Ferraro's supporters, on the other hand, have sometimes tended to portray her with oversentimentality. The typical picture they've given of her has been of a warm, efficient, loving wife and mother who adores grocery shopping and likes to lounge around the house in her daughters' clothes.

The point is that although Ferraro likes to be seen as the mother of a happy family, which we can assume she is, she also wants to be taken seriously as a talented, qualified politician. "When I rose through my House leadership, there was no question in anybody's mind that I was capable of doing the job," she told me in a phone interview. "If I had run for Caucus Chair this year, I might have won it, and no one would have questioned it or said that I got it because I was a woman. They would have said, 'She got it because she was very well qualified!'"

"But being the first woman candidate for national elective office in the United States is quite a different matter, a totally different thing," she said emphatically. "That was a charge leveled at me [that she was chosen to run because she is a woman]; I think that we dispelled that throughout the campaign by my behavior and by my ability to deal with the issues, in many instances better than the other candidates."

Ferraro's family history is as dramatic as her rise to national prominence in the 1984 presidential race. Her mother's parents

were poor Italians, living the typical life of the hard-working immigrant family in Manhattan. The father was a streetcleaner, the mother a dressmaker and Antonetta, Ferraro's mother, was the seventh of ten children. At the age of 20, Antonetta married the upwardly mobile Dominick Ferraro, and soon afterwards had twin boys. One died at three days of age.

Dominick Ferraro did well. He took his family to Newburgh, New York, where he owned a dime store and restaurant. Antonetta soon had another son, Gerard, but he too died—in his mother's arms in a car accident. Geraldine, born two years later, was named after him.

For a time, the family prospered. Dominick doted on his daughter, showering her with presents every month, treating her like a little queen. But suddenly another tragedy hit—he died at the age of 44, when Geraldine was only eight.

This third death in the family changed their lives dramatically. Antonetta invested her husband's money unluckily and lost it, so she had to go to work doing the only thing she had training in—dressmaking. She crocheted beads and sequins on fancy dresses in a garment factory. She had to move from Newburgh to a small apartment in the Bronx, then later to an even smaller one in Queens. Meanwhile, Geraldine stayed behind at her school, Marymount School, in Tarrytown, New York, as a boarder. Her fees were paid by a scholarship.

"When I was a kid," Ferraro told *People* magazine, "my mother wanted to give me everything every other kid had, and she couldn't afford to. So what do you do? Do you walk around and say, 'I want, I want, I want?' Or do you make do? Maybe the reason I got where I am today is that in school, in my work, in Congress, I worked harder than anybody else." Ferraro has also said that it was seeing her mother left alone and poor after her father's death that made her determined to have her own life and options, not depend on a husband for them. It was also in admiration for her mother's fortitude and in gratitude for her sacrifices that Ferraro kept her name rather than taking her husband's.

Continuing her habit of working hard, Ferraro won a scholarship to Marymount College in Manhattan. "It was fantastic because the entire city of New York was my campus," she said. "We had the best museums, the best theatres, the best libraries and the best opportunity to enjoy ourselves as well. It is during those formative years that one makes the determination of where one is going to go in the future, so I think this city, with all the resources it had to offer, really made a lasting impression on my mind."

Nevertheless, Ferraro's ambition at the time had nothing to do with politics. She simply shared the expectations of most educated career women of the 1950s—she decided to be a teacher. So, she began to teach at an elementary school in Queens. This did not satisfy her for long, though. With help from her mother, she started to attend law school at night, and that was when her interest in politics began. First, however, she took care of her personal life. She married John Zaccaro, had three children and was a full-time wife and mother until her youngest daughter was in second grade. Then she got a part-time job as a lawyer for her husband's real estate office and, eventually, began her climb up the ladder of law and politics. Ten years later, she was a Congresswoman from Queens and a candidate for vice-president.

Ferraro is clearly an exceptional person. She is able to ride out hardships, take pressure as a challenge rather than as defeat, and overcome all sorts of odds against her. As I read through the many articles about her in the national press and watched her cool, quick, informed, articulate and humorous addresses on television, my admiration for her grew. But what, I kept wondering, enables her to do all this? What has she got that's different? That is something none of these articles told me. So, I tried to find out for myself during the brief telephone interview she granted me from her Washington office.

"When did you start having hopes or dreams about doing so well in politics?" I asked.

"Well, I dreamed one dream at a time," she answered, speaking in those fast, bullet-like bursts of words she is known for. (Even the fact that she was eating an ice cream bar didn't slow her down.) "When I was in college I wanted to become a teacher, did that and decided on graduating that I wanted to become a lawyer, and I did that. I didn't, when I was in college, decide I was going to run for vice-president of the United States. It's been one step at a time, but because of the ability to respond to opportunities that have been offered to me, I've been able to move and take advantage of each one as it's come along."

"And how did you cope with all the pressures and expectations the nation had of you during the campaign? Do you have any motto or special method?" I asked next.

"Coping with pressures?" she said. She has a habit of summing up a question and repeating it as she forms the answer. "I cope because I'm the type of person who can cope. As I've grown up I haven't been given anything my entire life, I've always had to work for it, so you learn to deal with that. The expectations throughout the campaign were high. Both physically and emotionally higher than I had antici-

pated. But it's not something you just learn in three or four months, it's something you develop over a lifetime of dealing with problems as they arise. Do I have a motto? No."

"Didn't it ever get overwhelming though?" I said, marveling at her unflagging self-confidence. "Wasn't it hard to live up to such a role and be the first woman to do it?"

"No, no, no. That never got overwhelming. You know what occasionally got a bit much was the pressure placed on me by the press, but other than that it was not overwhelming. That ice cream was very good. Okay, now I can concentrate totally on you instead of my ice cream bar. Banana. It was good."

I still wanted to get an explanation of how she copes with pressure, so I brought up her televised debate with Vice-President Bush. There the pressure was enormous: she had millions of people watching her; she was following Mondale's victory over President Reagan in their TV debate with the expectation that she had to do just as well; Mondale and the Democratic party were counting on her; and, as she once put it herself, women everywhere were thinking, "God, I hope she doesn't blow it." And she didn't. While Bush got shrill, overexcited and emotional, revealing his sexism by refusing to call Ferraro by her title of Congresswoman, but calling her "Mrs. Ferraro" instead, she remained calm, reasonable, determined and solid—characteristics that in a man are always admired. She had to represent her party, her politics, her beliefs and her gender all at once, perhaps more of a challenge than any American politician has ever had to face in a debate. How did she do it?

"It was a challenge but it was a part of the job, so I met it," she said simply.

"But," I said, "didn't you ever worry about freezing up or going wrong?"

"No. I worried about making mistakes, but you worry about that when you go into a courtroom, too, as a trial attorney. You worry about that when you get up on the floor of the House to make a speech; you worry about it in the course of debate on the floor. Of course, the stakes are a heck of a lot higher in a vice-presidential debate, and sure I was worried about misspeaking. But not freezing up, no."

"Well, you'd had lots of practice, I guess," I said, thinking that her career as a trial lawyer and Congresswoman in the House of Representatives had at least got her used to debating under pressure and in public.

"Well, I don't know what you'd call lots of practice," she said. "Do you mean having done that type of thing before?"

"I mean being in trials and speaking in public," I said.

"A totally different thing. Absolutely totally different because number one, you have 80 to 100 million people watching you. Number two, you have the pressures of being the second on the ticket, at the same time having tremendous responsibility to the man who's at the top. And you also have a limited amount of time. And you have the points you want to make. You have to make a decision as to whether or not you are going to respond to the person on your right making debate points, or if you're going to try to bring a message to the American people, and that's something you have to decide split-second-wise every time you come up with an answer to a question that's been asked you. There's no training that one can have to do that until one does it."

"You once said that you don't rattle easily," I went on. "Has anything ever rattled you?"

"I don't rattle easily, and I can't think of when I've been rattled," she answered promptly.

Her answer made me think of a recent television talk show on which she was a guest. "To what personal quality do you attribute your ability to have survived the enormous pressure you were under during the campaign?" the host had asked her. "I think," she had begun, speaking more slowly than is her usual fast-paced style, "it is my ability to detach myself from what is going on around me, and to put all my energy into concentrating on what is happening at the moment."

After we hung up, I read through several more volumes of interviews with her. The problem with the public image of Ferraro, I decided, is that everyone has concentrated too much on her being a woman and not enough on her being a politician. Where are the family portraits of Bush, Reagan and Mondale? Where are the questions about whether Bush can bake blueberry muffins (a Mississippi Democrat actually asked Ferraro that in public)? Where are the descriptions of Mondale's "immense" gray eyes or Jesse Jackson's "mind of a heavyweight" or Gary Hart's "sensuality"? As Zora Neale Hurston, the Black folklorist and writer of the 1920s once told a reporter, "I don't see life through the eyes of a Negro, but those of a person." Ferraro might well say, "I don't see politics through the eyes of a woman, but those of a politician." Perhaps, however, Ferraro herself should have the last word where she is at her best—not as someone trying to squeeze into a stereotype, but as a public speaker and representative of the people:

"For two centuries, candidates have run for president. Not one from a major party ever asked a woman to be his running mate until

Walter Mondale. When he asked me to campaign by his side, he opened a door which will never be closed again. That is a victory of which every American can be proud. Campaigns, even if you lose them, do serve a purpose. My candidacy has said the days of discrimination are numbered. American women will never again be second-class citizens."

Charlayne Hunter-Gault

Charlayne Hunter-Gault:
Newsmaker, Newsbreaker

by Marianne Ilaw

WNET/Thirteen

> *In a sense, my whole generation is a generation of pioneers. My life has paralleled the development of the civil rights movement. The experience at the University of Georgia gave me the inner strength to get through some of those professional mine fields. I have tried very carefully to work my way through those mine fields so that I come out knowing where they are and being able to look back and tell somebody, "Don't step that way 'cause there's a big mine, and you can be destroyed by it."*
>
> *I spent a lot of time during that period talking to the reporters, interviewing the reporters about how they were interviewing me. As they were interviewing me, I was interviewing them. It was a learning experience. The double vantage point may have helped me to focus less on the horrendous things that were going on around me and more on the situation as a part of a process. If I had focused in a much more personal way, I probably wouldn't have been able to make it.*
>
> —*Charlayne Hunter-Gault, 1984*

It is four o'clock in the afternoon and reporter Charlayne Hunter-Gault rushes into her office at Channel 13's headquarters on West 58th Street. She has just returned from covering a story in the Bronx, and she is ready to tackle the piles of work that cover her desk.

Tall, pretty and poised, with flashing gray-green eyes, she slides behind her desk and pulls out a sheaf of pink typing paper. She thrusts it into her IBM typewriter and begins pounding on the keys. As she finishes each sentence, she reads the copy aloud to make sure that the words flow smoothly. She's working on a narration for a segment of that evening's MacNeil/Lehrer NewsHour, and the deadline is fast approaching.

Outside her office, in typical TV newsroom fashion, researchers shout into telephones, assistants bustle to and fro with packages and equipment, and harried-looking executives review the show's lineup. In private offices along the corridor, producers huddle in front of television monitors as they evaluate reports on videotape. But Hunter-Gault is oblivious to all of this activity as her fingers race along the typewriter keys. She looks up thoughtfully for a moment, whirls around, and punches the buttons on a desk-top computer to see what's going on in the world. The words on the screen tell her about the death of an infant who had just undergone heart transplant surgery. She shakes her head and sighs, "That's too bad," and returns to the work at hand. A cool professional who has been an eye witness to tragedy, excitement and history-making events, Hunter-Gault still can't totally detach herself from the news. She loves

people, she says, and "It's hard to separate the people from the issues."

Her telephone jangles and she reaches for the receiver, briskly answering questions about another story she's working on for the show. Her office is quiet now, except for the staccato beat of her typing and a soft "chik, chik, chik" sound. Charlayne has folded a stick of chewing gum into her mouth and is furiously working it over as she finishes her story. She looks up from the typewriter, grins impishly and tells a visitor, "I've got to do something when I type. I chew gum the way some people smoke."

On camera, she comes across as a no-nonsense reporter who would rather focus on the issues than on her image; in private, she doesn't feel the need to act the part of the glamorous television newswoman. "I don't consider myself a media personality, a celebrity," she says in her soft Southern accent. "I'm a journalist."

Charlayne Hunter-Gault, news reporter, was once Charlayne Hunter, newsmaker. In 1961, she drew national attention when she became the first Black woman to attend the previously segregated University of Georgia.

Under heavy police escort, she and a young Black man named Hamilton Holmes stepped onto the Athens, Georgia campus one blustery January morning, only to be greeted by hostile, jeering crowds. Although armed guards provided a measure of protection against potential physical assault, they could do nothing to protect the two young students from the stinging racial slurs tossed at them by the angry crowd.

For Hunter-Gault, the memory of those two-and-a-half years at the University of Georgia is still very much with her. For while her contemporaries were caught up with the normal concerns of college life, 19-year-old Charlayne Hunter was forced to cope with hostility and threats against her life, simply because she, a Black woman, wanted the right to pursue a quality education.

Although it was a difficult period in her life, Hunter-Gault believes that the experience gave her an inner strength, and, at the same time, helped her to develop a clear understanding of journalism, the field she chose as her college major. "It was a learning experience," she recalls. "The media coverage of our activities helped me to focus less on the horrendous things that were going on around me and more on the situation as part of a process. In my own case, I was able to see good reporters and how they fully covered the story. I was close to it, and I saw what the good ones did well and what the bad ones did poorly, and I guess I benefited from that. I spent a lot of time talking with the reporters and interviewing *them*."

Hunter-Gault had always known that some day she would be a reporter—a good one, too. As a child growing up in the small Georgia town of Covington, she eagerly followed the escapades of Brenda Starr, the glamorous comic-strip newspaper reporter who spent her days bouncing from one adventure to the next. But she had plenty of real-life inspiration, too. She credits two of her high school English teachers with being instrumental in her decision to study journalism. "In high school, my English teacher allowed me to correct the other students' papers, and that gave me a certain feeling of confidence and maturity at a young age," she remembers.

Although a quick learner, Hunter-Gault discovered early on that she was bored by sitting in a clasroom for hours on end: "I enjoyed getting out and not being confined to one predetermined, structured schedule. Since I worked on the school newspaper, I frequently had the opportunity to get out of class to work on an assignment." Her teachers instilled in her a love of literature and a curiosity about the world—two essential ingredients for the making of a good journalist.

The Hunter family also provided inspiration and support: "My mother was always there as a source of encouragement; she gave me a lot of room to grow, to explore. And my father was a very strong person, a perfectionist. I could come home from school with four A's and a B plus, and he'd say, 'What's this B plus?' He wouldn't even deal with the four A's, which used to infuriate me. But I did develop a standard of excellence, and I'm always striving to be better."

Her grandmother, too, was a positive force in her development, Hunter-Gault recalls. "She was one of the greatest influences in my life. She was well read, articulate and curious, even though she never got past the third or fourth grade. We used to get on the train and ride all the way to New York City; we'd go to Harlem and walk around the town. And we were from a little town in Georgia that didn't even have taxis!

"Yes, my family was very supportive. When I was young, becoming a journalist was a serious dream, for there were hardly any women or Blacks working as reporters. A school counselor told me to forget about those pipe dreams and become a teacher like all the rest of the girls. But never once did anyone in my family ask me where I got the fool notion that I wanted to be a journalist."

Charlayne never did believe that being female was a barrier to her success. "I never thought about whether or not I could compete with men, and I've never thought of myself as being inferior to them. My mother was strong and intelligent, and my father taught me to aim high."

She firmly believes that women can overcome sex discrimination in the working world, but she's quick to point out, "My situation is different from that of a lot of white women. The discrimination that I suffered first and foremost was as a Black person. Growing up in the South, I was not segregated because I was a woman, but because I was Black...Now I'm at the point where my concern is equal for both." She pauses for a moment and then relates an incident that she'll never forget:

"After doing an interview with a white man in his sixties, I was anxious to leave the studio in Washington to catch a plane back to New York. He asked me if I had a minute, and proceeded to tell me how much he enjoyed being on the show, how much he enjoyed the program in general, and how much he liked me in particular. I thanked him and started to leave. He followed me to the door. 'How long have you been doing this?' he asked. 'Close to 20 years,' I told him. 'You must really like it,' he said. 'I do', I responded, inching toward the door. 'Well, I guess it beats being a chorus girl,' he said.

"People to whom I have told that anecdote assume I blew my stack. But I didn't. The whole point of the man staying around was really to tell me how much he admired me. In his own way, he was struggling, given his age—his generation—and maybe a background that didn't prepare him to deal with women or with Blacks or with both. Still, he was making the effort to overcome whatever it was, and while it was awkward, to say the least, to me it was progress. I smiled at his comment and said, 'I suppose it does.'"

Fresh out of college, Hunter-Gault was offered a job as an editorial assistant at the prestigious *New Yorker* magazine. It was a mixed blessing: "I may have started at the top, but I started as a secretary. I could have stayed a secretary if I hadn't really worked hard to become a writer."

After a year of typing envelopes and sending out rejection letters to would-be writers, Hunter-Gault was promoted to the writing staff of the magazine, where she contributed to the popular "Talk of the Town" column.

Working at the *New Yorker* gave her valuable experience and helped sharpen her writing and reporting skills. Her talent was quickly recognized, and she soon won a Russell Sage Fellowship to study at Washington University, where she joined the staff of *Trans-Action* magazine. In 1967, she made her debut in broadcast media as an investigative reporter and evening news anchorwoman for WRC-TV in Washington, D.C.

The following year marked a turning point in her career. She accepted a position on the metropolitan staff of one of the mostly

highly respected newspapers in the world—the *New York Times*. Her expertise in Black and minority affairs led to the establishment of the paper's Harlem Bureau, with Hunter-Gault at the helm. Although a job with the *Times* would represent the zenith of most reporters' careers, the young Southern woman took her new-found status in stride. As she says now, "I haven't been in awe of any institution I've worked for, not after what I've been through. I've fought a lot of battles; I've won some and I broke new ground. I was able to write about Blacks as people instead of as statistical incidents. That was the most challenging thing—to present the Black community in a fuller light than had been exposed in the media before. That's not to say that there weren't negative things, but it became obvious that Black people were doing things like everyone else, that there was a range of experiences within the Black community.

"I really liked walking the streets of Harlem and talking to people. The stories that give me the most satisfaction are stories about people. One of the qualities a good reporter possesses is the ability to get excited about almost anything. If you have that capacity—and I think I have—you tend to get excited and give it your best."

Hunter-Gault spent eight years at the *Times*, but took a six-month leave of absence to co-direct a fellowship program for minority journalists at Columbia University. In 1979, she joined the MacNeil/Lehrer Report, a nightly half-hour news program that offered in-depth analyses of topical world and local issues. In 1983, it expanded to 60 minutes and was renamed the MacNeil/Lehrer NewsHour. This new format gave Hunter-Gault increased visibility and an opportunity to tackle more extensive assignments.

Her day typically begins at 10 A.M. with a staff meeting to discuss fast-breaking news events and future story ideas. During the course of the day, there are more meetings with producers, directors and researchers, and in between, she's either out on assignment, in the studio recording a voice-over, conducting interviews or writing and editing scripts.

She says, "My day is jam-packed from morning to night!" From the moment she arrives at the office until the time she wraps up (about 8 P.M.), Hunter-Gault is on the go. Sometimes her schedule is so full she can't even break away for lunch. "You'd be amazed at the number of tasks I can do simultaneously," she says incredulously. "This program is very different from most television news programs; here, there's a lot of writing and analysis. It's a lot like working on a newspaper, and my assignments give me the opportunity to develop an appreciation and understanding of the experiences of all kinds of people."

Although she claims that all her assignments have been memorable ("A good reporter will use her creativity to make even the subject of sewers exciting," she says.), she cites her coverage of the 1983 invasion of Grenada as "a rather unique experience." When the United States sent troops down to the small island to help restore peace after a bloody coup d'état, Hunter-Gault flew to the scene to an on-location report. "Grenada was a multifaceted story," she recalls. "We tried to tell the story through the eyes of the Grenadians. And while I don't think that my coverage of the event qualifies me as a war correspondent—after all, it wasn't Viet Nam—it *was* an unusual experience."

"I don't ever think about what else I would do if I didn't have this job, because the challenges are still coming, and the opportunities are still wide open and attractive. I like what I'm doing. Every day is full to the brim. One minute I could be at my desk working on a script, and the next thing I know, I could be flying down to D.C. to interview Lena Horne at midnight, because that's the only time she's available and it's crucial to something I'm working on.

"This job offers the best of all possible worlds, and the level of psychic satisfaction is very high. I'm always learning—if I want to know about law, I do stories about legal issues; if I want to learn about medicine, I do stories about doctors or health issues; if I want to know about business, I do stories about what's going on in the corporate world. I can satisfy my curiosity by talking to everyone. They can't do what I do, but I can find out about what they do."

In her advice to would-be journalists, she stresses the importance of a broad and varied store of knowledge, and also tells them, "I believe firmly that even in this age of computers and specialization, a liberal arts education is paramount." As she explains, "Students need to take advantage of that once-in-a-lifetime opportunity when they have the chance to read the classics, study literature and get a basic understanding of economics. I still have some questions about whether or not journalism school is the best preparation for a career in journalism. I tell students: Why not go to law school? Or business school? Or just go to Europe and travel? Learn another language— I'm teaching myself Spanish now. I tell minority kids and women who want to become reporters that a good, solid liberal arts education is crucial, perhaps with some kind of post-graduate specialty. I say, 'Look, you've got to go in to these editors with something other than your color and your gender to sell. Something that says I'm different from all the others.'"

She is especially concerned about presenting herself as a positive role model for young Blacks and women. In addition to speaking

before student groups, Hunter-Gault tries to offer informal personal career counseling to aspiring journalists. "When I get resumes from students, I try to keep a little file, I try to help them when I can," she says. "And when I get letters, I like to answer them personally, whenever possible. I figure if someone took the time to write, I should take the time to answer.

"To be in a position like this and not be able to help somebody now and then would be a very empty existence. Many times young people just want to talk, to know that somebody else has done it. Every time you do something for someone else, it's rewarding."

She's glad to see women playing more significant roles in politics and business, but she cautions, "Women who are new to the work world should realize that they're going to stumble somewhere along the line. Stumbling is human, and yet, when you're new to a situation, you feel you're the only one who has made a mistake. But one should always profit from one's mistakes and not allow them to weigh you down. When people are in the minority, the only woman, or the only Black person, first the external pressure to succeed is great, but the internal pressure is great, too. You're thinking, 'I've got to prove myself.' Well, of course you've got to prove yourself, but not by some extraordinary standard. Having high standards is fine, but those standards need to be realistic, because if they're unreasonable, they can be counterproductive. You need to maintain a delicate balance."

Hunter-Gault continually evaluates the quality of her work in order to maintain her self-imposed standards of excellence. She says, "I want to be remembered as a good journalist and a good person ...people who know me know me for what I do, and they know I do serious journalism. That's been my life, that's the thing I've really worked at.

"And I think that being a woman in New York City is getting easier and easier. So many barriers have been broken. Take Geraldine Ferraro, for example. This is where you see very concretely the importance of pioneers and role models. Because a woman can look at Ferraro and say, 'If she can do it, I can do it.' Maybe this will get more women out of the house and into the local political club, or maybe it will just get them to read the newspapers more often to see what's going on around them.

"This isn't to say that barriers don't exist, that old attitudes don't die hard, or that the battle to be recognized for your ability rather than your gender is won. But I do think that with women being so visible in this city, doing important and responsible things, it just makes it easier for other women at all different levels."

Hunter-Gault stops talking for a moment and glances toward the clock on the wall. It is close to air time and she must hurry down to "make-up."

The make-up artist greets her and appraises her outfit: a soft mauve blouse and a bright flower-print skirt. As she deftly brushes gleaming lavender powder onto the newswoman's eyelids, Hunter-Gault stretches her legs, settles into her chair and begins to talk about the most important "assignment" in her life: her role as wife to New York City Department of Employment Commissioner Ronald Gault, and mother to a daughter and a son—20-year-old Susan and 12-year-old Chuma.

"Everybody here knows that my children take priority, even if I'm about to go on the air," she explains. "My kids have learned shortcut language when they call me, but they know that what's important to them is important to me."

She does admit that "It's difficult to have a family and career, but it is manageable." The Gaults hire a housekeeper to help maintain their spacious upper West Side apartment—"I'm not that fastidious about cleaning," she confesses.

Although husband and wife make a special effort to set aside time to spend together, sometimes their equally hectic schedules don't even permit a brief telephone conversation. She recalls one incident in particular: "I was in Grenada, Ron was in Israel, and he didn't even know I had been sent down there! He called the office, and they didn't know exactly where I was, because it was hard to get through to the island. But I called him when we arrived in Barbados, and I haven't heard him that happy since we got married!"

Hunter-Gault treasures the time she spends with her family and says that playing tennis, cooking and dining out are favorite pastimes. When she's alone, she likes to curl up with a good book, preferably something by Zora Neale Hurston, Alice Walker or Ntozake Shange. Charlayne also finds time to write free-lance articles for *Essence*, *Vogue*, *Ms.* and the *New York Times*, among other publications.

Although she describes Susan and Chuma as "great writers," she won't insist that they follow in her footsteps—"I let them do what they want to do, and I try to treat them the way my mother treated me; I'm not unhappy with the way I turned out." She explains, "I've always had a maternal instinct. When my first brother was born, I was like a little mother to him." As the first-born and the only girl in the family (she has two brothers), she claims she was "a very independent child."

Naturally, Susan and Chuma are extremely proud of their mother's achievements, and she happily accepts invitations to their schools to discuss journalism, careers and her own experiences. (Susan majors in drama at Sarah Lawrence College and Chuma attends junior high school in Manhattan.)

Although a talented, accomplished journalist who welcomes the challenges and opportunities of her profession, Hunter-Gault claims that of all the awards, honors and commendations she has earned, perhaps none are as significant as this letter her son wrote in 1984:

Dear Mom:

Guess what? The teachers today nominated you [for the] "Ms. Magnetism of the Year" award in school. Everybody was making great comments about you. Remember when I said I didn't want you to come because I thought things wouldn't go well? I was wrong. It went fine. Even now, as I write it, there are murmurs of excitement and appreciation spilling over from your presentation.

I just wanted to say—congratulations. You're doing fine.

Love, Chuma

Amalya Kearse

Amalya Kearse:
A Judge with High Honors

The New York Times

by Roslyn Lacks

> *I find almost every case I've written an opinion on to be very interesting. I enjoy the process. I like the research, and I like to write. It's a good thing, since it's a large part of what this job is all about. I'm always pleased when I can work my way through a tricky or intricate problem and come out with what I think is a reasonable and logical answer to it that applies the law properly. The process itself is gratifying, and I enjoy it.*
>
> —*Amalya Kearse, 1984*

Lawyers for defense and prosecution argue their cases before three black-robed judges in the august wood-paneled courtroom of the nation's second highest court, the United States Court of Appeals, Second Circuit on Foley Square in Manhattan. Two of the three judges hearing appeals this morning are white-haired men; the third is a younger, slender Black woman. She is Amalya Kearse.

Appointed to the Court of Appeals by President Carter in 1979, Kearse is the first and only Black woman to serve on any federal circuit court of appeals, and she is the first and only woman among the 16 judges who sit on the Second Circuit Court.

Five cases are being argued this morning before Judge Kearse and her two colleagues. The first involves the possession of more than a kilo of cocaine by a suspect apprehended at Miami International Airport.

The case of the "high-heeled" heroin is second. Here, an alleged international courier of heroin from the Middle East was stopped by federal marshals when his plane landed in Detroit. In searching his luggage, they found over a pound of heroin secreted in the shoulder pads of men's suits and in the high heels of women's shoes. His lawyer maintains the luggage was planted, citing as evidence the fact that when his client tried them on in court, the suits did not fit him.

"Apparently, the shoes didn't either," murmurs Judge Kearse, providing a welcome moment of laughter in the austere courtroom.

The third case concerns a figure, scheduled to testify before the President's Commission on Organized Crime, who was careless enough to leave a briefcase containing $8000 and incriminating documents at a suburban shopping mall. His lawyer contends violation of the exclusionary law, concerning admissibility of evidence. (Evidence that has been improperly obtained cannot be used against a defendant in court.) Here, the defense claims that the police kept the briefcase for several days before returning it, long enough to copy the damaging information it held. The defendant does not want

such information used to incriminate him, should he testify before the Commission on Organized Crime.

The fourth case moves from crime to labor law, contesting the amount of interest due on back pay for women hospital workers under an anti-discrimination ruling made in lower court. The fifth centers on environment, with a suit brought by an environmental protection group against the U.S. Department of Interior and a hotel chain that wants to turn some acres of upstate New York woodland into a golf course.

With the morning's docket cleared, the judges rise, dismiss the court, and retire to the disrobing chamber. Here, they hold a preliminary discussion on their judgment of the cases and the rationales involved in resolving them. They then take a tentative vote on the resolutions, dividing up among themselves the task of writing opinions.

By afternoon, Judge Kearse is back at her desk, ready to begin writing, to review briefs for the following day's cases, or to prepare summary orders for the cases she has just heard.

"Not all cases require full opinions," she explains. "Some have no real jurisprudential significance. While the parties are entitled to decisions, the cases don't raise any new issues of law. When two or three decisions on a particular point of law are already in the books and the case before us is governed by that without any new factual wrinkles, we issue a 'summary order,' which is usually a very brief statement of our findings on the case."

Were this morning's cases typical of those that are appealed before the court?

"No one morning's cases can be typical, in a sense," she replies. The court hears a wide gamut of appeals, about one-fourth of them criminal cases and a high concentration of them, commercial ones. Another morning's cases, for example, included a tax case involving charitable institutions, a breach of warranty case over the sale of robots, and a Social Security case appealing for the reinstatement of disability benefits.

Judge Kearse hears arguments in about two dozen cases a month, ten times during the course of the year. Another dozen or so cases a month come to her for decisions. (Not all cases are argued before the three-judge panel.) The panel itself sits almost every week from September through June. Over the summer, court is in session for one week in both July and August, with a judge always on duty for emergency matters. Altogether, 11 active judges sit on the Second Circuit court, in addition to four or five senior judges—those who

have reached retirement and may opt to work as little or as much as they choose.

"Fortunately," Kearse notes, "ours work most of the time."

And so, too, does Amalya Kearse. She is known to her colleagues for her exceptional intelligence and her long working days. She tries to manage two or three hours of tennis a week—at the Wall Street Racquet Club—and to spend as much time as possible at her house in Connecticut during the summer, where she can play tennis every day. But she invariably carries work home to her Greenwich Village apartment when she leaves in the evening.

"I almost always prefer reading briefs at home rather than here," she comments. "It seems to go a lot faster there. Possibly," she adds, "it's because here my clerks wander in and out when they need books, or I may think of things I want them to do; so when they wander in, we start talking about things that they had no idea they were going to discuss when they came in." Judge Kearse works with a staff of two secretaries and three law clerks; the clerks are recent law school graduates who stay with her for one year.

Occasionally, after a long evening of reading legal briefs, Kearse turns to her guitar. "I sometimes decide to play a song or two before going to sleep," she says, "but I usually end up playing an hour or more."

Amalya Kearse grew up in Vauxhall, New Jersey, a suburban community, half an hour's drive from New York. Her father, who died in 1968, was postmaster in the town; her mother, Myra Smith-Kearse, who died several years ago, was a practicing physician. Born in Virginia, Myra Smith graduated from Howard University's Medical School in 1925. Two of her uncles practiced medicine in New Jersey, and in 1927, Myra Smith established her own practice in Vauxhall. It was there that she met and married Robert S. Kearse. Myra Smith-Kearse continued to practice medicine while Amalya and her younger brother were growing up. Her specialty was pediatrics, but she treated people of all ages.

"Vauxhall is a pretty small town," Judge Kearse notes, "with only two or three doctors." After retiring from medical practice in 1967, Dr. Kearse was called on to run Union City's anti-poverty program. (She had been active in committees that initiated the program, and stepped in when the program lost its director.) She subsequently served as director of a day care program. "Both my parents," says Kearse, "were very much involved in community work."

While there were "lots of doctors" in Amalya Kearse's family, she is the family's first lawyer. Her father, she suggests, would probably

have become a lawyer, had not the Depression precluded any possibility of his attending law school. Her younger brother works in finance, specializing in securities and mutual funds.

"I think I was headed toward law school from junior high school days," Judge Kearse conjectures. "I'd read some Perry Mason mysteries and enjoyed some other novels about the law. [She still reads mysteries—when she has the time.] I like making arguments, like to compete, and like logical processes. That's a combination that sort of suggests law."

Kearse entered law school at the University of Michigan upon graduating from Wellesley College, where she majored in philosophy. Out of 350 students in her first year law school class, only eight were women. Of these, four completed their training at Michigan, three dropped out after their first year, and one continued at another school. The class that preceded hers had no women at all.

In addition to her outstanding achievements in law, Kearse is one of the leading American bridge players, having won many titles in national championship games. She has written numerous articles and several books on bridge, and has translated two books from French into English. Like her interest in the law, her enthusiasm for bridge dates back to her early teens. Both parents played bridge and taught it to the two younger Kearses, providing a ready family foursome.

"My friends in high school were also just learning," she recalls. "We used to go to each other's houses and have bridge games." She laughs. "My recollection is that we were pretty terrible at that stage!" During her second year at law school, a friend introduced her to duplicate bridge, the form that is favored in tournament playing.

When she was sworn in as a federal judge in June 1979, friends and family attended a reception in her chambers following the ceremony, and decided to go out to dinner together afterwards.

"There were about a dozen of us," Judge Kearse recalls, "and we settled on a nice midtown restaurant. I had driven to court that day. Since I have only a two-seater, my mother and I drove up together, while the others followed—in their own cars, by taxi, or by public transportation. My mother and I were first to reach the restaurant and were seated at our table. When the next person came in, she asked if Judge Kearse and Dr. Kearse had arrived yet.

"Oh no,' she was told by the maitre d', 'there are just those two ladies sitting at a table over there.'"

Even fewer "ladies" were chosen for the law in 1962, when Amalya Kearse graduated from law school with the kinds of honors

that would have sent law firms scurrying after her, had she been a white male. (Most law firms canvas college campuses, holding preliminary interviews with students. Those who are being seriously considered are then invited to return for more extensive follow-up interviews at the law firms.)

"I had a lot of interviews with New York law firms on the Michigan campus my third year," Kearse remembers. "At that time, there were no Black lawyers on Wall Street, as well as very few women. I did not get very many invitations to come back to New York," she remarks with characteristic understated irony. "One firm's interviewer told me that they had only recently starting having women secretaries," she recalls, the barest hint of laughter underlying her customary reserve, and that "they couldn't possibly add a woman lawyer!" The laughter bubbles forth.

How did she respond to the obstacles that confronted her, knowing that she was at the top of her class and would have been sought after, had she not been a woman and Black?

"I had to take no for an answer when it was given," she replies evenly, "but that didn't stop me from trying someplace else. I wanted to come to New York to practice and just knocked on doors until I found a place where I wanted to work and that would give me a chance."

"The people at Michigan's placement office were quite candid about the problems I was likely to encounter, so I didn't expect to have an easy time of it," she adds, "and I didn't. One interviewer looked at my resume and said, 'God, I wish you were a man!' When I was looking for a summer job following my second year in law school, the first person I saw told me I was too early because they hadn't yet started hiring people for the summer; the second told me I was too late because they had completed their hiring." She laughs. "There were all kinds of incidents like that, but you can't be stopped by them. You just have to do what you want to do and keep on until you find somebody who operates on a rational basis."

What about the job she landed during her last year of law school? Amalya Kearse joined Hughes Hubbard & Reed, one of New York's top ten law firms, as an associate in 1962. She was made a full partner in 1969 and remained with the firm until 1979 when she was appointed to her judgeship. What made for the match between Hughes Hubbard & Reed and Amalya Kearse?

Indeed, it is her own sense of humor—a quick, ready wit that finds its home in irony and understatement—as well as an appreciation of it in others that brought the two together. She remembers the

campus interview as "one of the most interesting" she had. "It was more relaxed. I liked the people I saw; they seemed to have a sense of humor." Hughes Hubbard & Reed was a middle-sized firm with 40 to 50 lawyers, none of them women. What most impressed Kearse on a return interview was learning that one of the women who had been an associate in the past would have become a partner, had she stayed on.

"That was basically unheard of in those days," Kearse observes. "How nice, I thought, that they take women seriously." Another compelling inducement was the firm's strong emphasis on litigation.

"The same competitive instinct that led me to law in the first place," she suggests, "led me to litigation: trying cases or getting them ready for trial and arguing appeals and motions. Our clients were mostly large or middle-sized corporations like Ford Motor Company and Broadcast Music. It's a firm that takes its work very seriously with very little pomposity. They were genuinely looking for someone who would do the work well."

During the course of her partnership, Kearse herself served as head of the firm's hiring committee. Did she make a point of hiring women?

"I made a point of hiring the best people possible," she replies crisply. "A lot of them were women."

Opportunities have opened up, and more and more women today look toward a career in law. At Wellesley, Amalya Kearse was one of only two women in her graduating class who went on to law school.

"Today," she observes, "more than one-third of the class goes on to study law."

"The law," suggests Kearse, "is an attractive profession, not just in and of itself, but as a jumping off place. It's not at all uncommon for someone to become a business person after starting out in a legal career; many go on to teach. I find the law interesting in itself, and I think it intrigues a lot of people."

During her first year in law school, Kearse lived in a cooperative house on the Michigan campus. Eighteen women lived in the house; 16 men would come there for meals. Most were working on their graduate degrees in a variety of subjects; only two or three were in law school. But virtually all of them were intrigued with Kearse's moot court cases (hypothetical cases tried by law students in a mock court for practice), and generated lively discussions about them.

"I think it was one of the things that helped me win the moot court," declares Kearse. "When I was researching my moot court

problem, I'd spend the afternoon in the library and come home with ideas. Over dinner, I'd discuss the ideas with the people in the house. They were terribly interested in my arguments and would quiz me on them. By the time I got to the oral argument of my case, I had already been through anything the judges were likely to throw at me!

"About half a dozen of these friends came to hear the arguments. None of them were lawyers; none had any legal training. My opponents were not all that sharp," she recalls. "I think both of them dropped out of law school after a year. But the comment I got from the judges was that the people in the back of the room knew a lot more about the case than did my opponents!"

Advice for young people who are considering law school?

"Probably the best piece of advice I could give," says Judge Kearse, "is don't go to law school unless you want to be a lawyer or want the kind of training that law school offers. It's an arduous training, especially the first year when you learn to think about things in a way that is probably quite different from the way you've been taught to think about them in college.

"In college," she explains, "you do a lot more theorizing with broader perspectives—a kind of broad brush painting with respect to the doctrines of whatever discipline you're trained in. Law school requires a lot more detailed, analytical thinking. Although you still want to keep an eye on the big picture, you learn to do more parsing and dividing before you go back to synthesizing. You learn to think about things in a different way. You need the earlier experience, as well as the law school experience; I'm not at all saying that broad brush isn't desirable for many things. It's valuable training, but you can't expect it to be as valuable to you in law school as it was in college. Law school provides you with a different approach to problems and to finding answers for them.

"Once you're out of law school, for example, you may be called upon to advise someone with whom you're working in a law firm. Frequently, you won't know what the answer is, but your job is to find it. Law school teaches you how to think about the question and where to look for the information that will help you reach a conclusion. There may be no specific answer to a given problem, but you still do the best you can in coming up with as reasonable a solution as possible.

"Anybody who goes to law school and wants to do well," Judge Kearse stresses, "has got to expect to work very hard, especially in the beginning, in order to understand what is required."

Amalya Kearse came directly to New York after her own graduation from law school and has remained a staunch advocate for living in the city ever since.

"Opportunity and challenge are what brought me to New York," she observes. "I think it's a great place to live, but I wouldn't necessarily want to visit. There's too much to do to take advantage of on a visit; it's much easier to take advantage of the city when you live here."

Paule Marshall

Paule Marshall:
Filling Silences with Strong Voices

John Pinderhughes

by Helen Benedict

I grew up with women being the most dominant figures in my life. This wasn't to say I didn't like my father—I did. He was a charming person. But it was those women, those West Indian women whom I write about in Brown Girl, Brownstones, *who figured so strongly in my life. As a little girl, I spent all my life with them! And it seemed to me, because they were so assertive and had such a strong sense of themselves and were constantly battling against being reduced and dismissed because they were Black and women and immigrant and working class, that they held up the world.*

I remember taking a trip once up to the Cloisters. We took the Fifth Avenue bus, which in those days was a marvelous ride because they were double-decker buses. From that top deck once I saw the Atlas there at Rockefeller Center holding up the world. And I thought of that as my mother! Without her, the world would just pht—collapse!

—Paule Marshall, 1984

Paule (pronounced Paul) Marshall's mission as a writer has been, in a way, to present these strong, Black women to the world. Her first novel, *Brown Girl, Brownstones,* published in 1959, is the story of Selina, a young girl growing up in the West Indian neighborhood of Brooklyn. In it she celebrates them through the mother, who battles against poverty, racism and a bad marriage to move up in the world and defy it with her pride, and through the heroine, Selina, who is determined to become her own person in spite of the ambitions her mother and her community hold for her. In her second novel, *The Chosen Place, The Timeless People,* which came out in 1969, she introduces Merle, a woman who takes the suffering of her people and the evils of the world deep into her heart, yet bears up under them with defiance and wit. In her latest novel, *Praisesong for the Widow,* published in 1983, Avey Johnson is "a middle-aged, middle-class Black woman, very composed, very correct, who moves from a kind of ignorance and total acceptance of all things American to a kind of enlightenment and questioning that enable her to establish a psychological distance between herself and some of the destructive "features of American life." These are just the heroines; many more such women populate her novels and short stories.

"The women I grew up with were larger-than-life figures to me," Marshall says now. "But then, as I grew older and had my own experiences working, going to college, encountering discrimination and the ways society let me know that I was, as they saw me, 'a lesser person,' I wondered, how am I to reconcile this with the very strong women I'd known as a little girl?

"So I began to understand the attitude of the society toward all of us Black women — sexism and racism. And to realize that the talk in that kitchen in my brownstone house was a way for those women to reassert themselves, to deny the image that the world had of them. And I also began to realize, as I read books in the library more carefully, that I didn't see myself or those women reflected anywhere in literature. We just didn't exist!

"So, when I started writing *Brown Girl, Brownstones*, I had the sense that I wanted to tell their story. The world of those women was just passing away, and I wanted to get it down on paper before it all vanished. On an even less conscious level, I had the desire to enshrine them on paper.

"Black women are *so* remarkable! They have so much to offer, not only to other Black women, but to women in general, and to men! It's important that their story be told. There are many different stories, of course, and I don't purport to say it for all Black women, but certainly for the ones that were part of my life."

Marshall herself easily qualifies as the kind of woman who "holds up the world." Her strength is quiet, subtle, but unmistakable. She isn't imposing—not particularly tall, slightly built, youthful for her 55 years and pretty, with high cheekbones, wide, clear eyes and only a touch of gray in her short, natural hairstyle. And despite a light, girlish voice, she gives the impression of someone you don't fool with. She concentrates intensely as she talks, speaking in spurts, with long pauses in between as she carefully selects her words. She also seems supremely self-reliant. Her life now is somewhat solitary, with her son grown and living in Newport, Rhode Island designing boats, and her husband long since divorced from her, but she seems to have chosen it to be that way. She dislikes talking on the telephone and sees friends only occasionally. When she is at home and not off teaching at one university or another, her life revolves around her work.

"When I'm really involved in a book, I try to get started on it early and work from about 8 o'clock to 1:30 or so," she says in her soft voice. "Then I take a leisurely lunch, maybe a nap and a read, and I take a walk. By then the day is pretty much over. By the time I've put in that morning of work, I need the rest of the day to recover!" She laughs suddenly, a flash of sassiness breaking through her self-contained demeanor. Then she adds, serious again, "It's a very simple and it would seem rather a dull life, apart from the work."

Marshall's work, as she calls her writing, has not come easily. Having to support herself and bring up her son has eaten into her writing time, one of the reasons, she says, she has produced relatively

little, and she writes very slowly. "I have to work all day to produce half a page that I won't throw out the next day." Also, for most of her writing years, her work was not commercially successful, although it always did well critically. Even though today's long-overdue surge of interest in women's writing is now bringing her attention, her lack of funds still shows in the way she lives. From her apartment, the same one she's had for 25 years, on upper Central Park West, you can hear the sounds of cars on the street and the A train rumbling below at regular intervals. She owns no car and, as she says, "no fur coats. As a writer, you learn to live on the edge financially," she says. Very few writers ever do support themselves by writing alone, and Marshall does it now by teaching at various universities and colleges for six months out of every year, an existence she calls "uncomfortable."

The apartment itself, although not fancy, is pleasant. Her living room, facing Central Park, is painted a dark, creamy yellow, which, with the deep brown of her wooden furniture, the leather couch and the glossy black grand piano in one corner, has a warm, lush feel to it. A tall Floridian plant stands near the piano, a pretty blue bottle of Jamaican rum rests in a basket next to the couch, and the walls are decorated with posters announcing African art shows and a painting of Black field workers. The apartment rather neatly combines an atmosphere of city life with the lushness of the West Indies. The place represents, for Marshall, the embodiment of a childhood dream.

"I'm a real Brooklyn girl," she says, smiling. "I was born right on Fulton Street—my mother didn't get to the hospital fast enough. I went to junior high and high school in Brooklyn and, eventually to Brooklyn College. During the time I grew up there, in the section that's now known as 'Bed-Stuy,' Brooklyn was known as the borough of churches and baby carriages and, to my mind, it was the dullest place in the world. My great ambition was to cross the East River and move to Manhattan!"

Yet, Marshall's childhood world was not all that typical, nor all that dull. She may have been "just a Brooklyn girl," as she puts it, while out on the streets, with a Brooklyn accent and speaking Black English with her friends, but once she stepped into her brownstone house, all that changed.

"Then I instantly became a West Indian girl with my accent even changing!" she says. "The power of the world that they created in that house, the West Indian world, was so strong that I had this dual cultural experience from the very beginning. My books come out of different needs, but they're all part of an ongoing effort to define

myself and to reconcile these dual cultures that have gone into making me, and to define what it is to be a Black woman in the world."

Marshall temporarily escaped from Brooklyn when she was grown, rid of both her Brooklyn and Barbados accents (something she did on purpose to avoid being teased, but now regrets) and ready for college. She enrolled at Hunter College in Manhattan. Yet, in a sense, she was still in a trap, for in those days, the late 1940s, women were expected to major either in English, with the goal of teaching elementary school, or doing social work. Marshall became a pre-social work major, ignoring her hidden desire to write.

In her sophomore year, however, her life changed. She became seriously ill and had to leave college for a year. She went upstate to rest, where she spent a great deal of time reading and ruminating.

"I realized that I liked people but I didn't want to work with them. I didn't want to be a social worker!" she says, clasping her knee and leaning back against the couch. "I remember writing to a friend at that time, describing the part of the country where I was living, and he wrote back and said it was such a beautifully described scene that why didn't I think of writing? It was as if he had signaled the thing in me that I had been unable to admit, even unconsciously."

So, tentatively, she decided to drop social work, switch to an English major with an emphasis on creative writing and to transfer from Hunter, in those days all female, to the coed Brooklyn College—even though it meant returning to Brooklyn.

After she was graduated—she did not want to follow in the footsteps of most English majors and become a teacher—Marshall decided to look for a job in journalism or publishing against the advice of her guidance counselor, who thought this was plain foolhardy. This was in 1953, an era when there were few Blacks in top jobs. She looked for almost two years, getting to know a part of Madison Avenue—then "Publishers Row"—so well that, she says, "You could have put me on the corner of 42nd Street and Madison blindfolded, and I could have found any one of those places." She tried *Mademoiselle, Time, Life,* various publishing houses and everything in between over and over again, getting nowhere. She calls it an agonizing experience, and has re-created it in her novel, *Praisesong for the Widow* when Jay, Avey's husband, tries hopelessly to find a job as an accountant.

"The thing that used to outrage me the most was the fact that they never really intended to give me the job," she says now, her jaw setting slightly. "There was a ritual that took place in nearly all the

offices: they'd send out for tea or coffee for me and sit with me and chat. They would make some positive sounds about my record in school, the fact that I graduated Phi Beta Kappa from college, and, sometimes, I'd be on my way down in the elevator before it had actually gotten through to me that I had not been offered the job!"

Nevertheless, with a determination and drive born, perhaps, out of her Barbadian background, Marshall persisted. Until finally, one day, walking along 43rd Street, she happened to glance up and see a sign in a dingy window that said OUR WORLD MAGAZINE. She knew it to be a kind of "second-rate Ebony" that she had seen in dentists' offices and, on the spur of the moment, she walked in and asked to see the editor.

"And strangely enough, he was willing. I think he was a little amazed by my audacity for those days," Marshall laughs. "He was a brilliant man, a Black man by the name of John Davis, a Rhodes scholar. He was kind of taken with me and said, 'Well, what do you think you know?' I said, 'I know absolutely nothing. I'm just trying to get some experience by getting a job.' And so he said, 'OK, I'll give you a chance.'"

She was hired, first as a researcher and, before long, as a writer. In some ways, the job was glamorous—she was sent to the West Indies and Brazil to cover stories, put in charge of Foods and Fashion—and it taught her to write quickly and under pressure, but, deep down, she was dissatisfied. The emphasis of the magazine on the high-life entertainers, on trivia, frustrated her. She longed to write about something more serious.

"So, in sheer desperation, I went home one evening and started working on *Brown Girl, Brownstones* in the hopes of providing an antidote to what I was doing all day long. And, in a sense, it was a novel waiting to be written. That first draft was a real kind of outpouring."

Unlike many writers, Marshall did not entertain dreams of fame and glory. She didn't dare think of publication, for, as she put it, "Once you put it out there, you discover whether you have talent or not!" So she approached the idea of publishing gradually. She joined writers' workshops at the Harlem Writers' Guild. "I just needed to be with other people who were doing this absolutely frightening thing." And after a couple of years, when she had a 600-page manuscript lying on her desk, she finally decided to send it out.

At this stage, most writers try to find an agent who has contacts in the publishing world, but Marshall didn't know about any of that. She simply picked up the telephone book, looked up "Publishing Houses" in the yellow pages and took the first name off the list she

recognized—Bobbs-Merrill. She bundled up her tome and sent it off. It languished on the editor's desk, unread, for a year, keeping Marshall on agonizing tenterhooks.

"I was in a dilemma. On the one hand, maybe their keeping it so long meant they were interested. On the other hand, I wanted to pick up the phone and say, if you don't want it, send it back."

At last she heard from the editor. He said he was interested but was having trouble with the company. A while later, her manuscript came back, rejected. The editor had left.

"But I still hadn't learned my lesson!" Marshall says with a proud tilt of her head. She sent it off to Random House. And they wanted it.

"But my editor said that when I received my advance, which was something like $2,500, I was to take my bloated manuscript and go off somewhere and extricate the lovely novel that was buried in the fat," she says.

But this was the early 1950s, a time that was not receptive to Black writers, especially female ones, as Marshall soon found out.

"The day I received my contract in the mail, I was so excited! It was the same day that I had a meeting with my editor to talk about the changes that were needed in the manuscript. I was so elated! Contract in hand, I went over to meet him. On the way, I ran into a Random House executive. He stopped to have a few words with me, and the upshot of his remarks was that he said in parting, after the usual pleasantries, 'Oh, you know, nothing very much happens with this kind of book.'

"I was utterly devastated. The contract I had in my hand felt like a rejection slip." Marshall stopped talking, frowned, and stared ahead at the wall.

"As I've reflected on it over the years, it seemed to me that he was not only saying that Random House wasn't going to put much into publicizing and pushing that book, but he was saying something which has to do with women and writers, especially Black women: that, as far as he was concerned, the book wasn't really part of American letters." She paused and shut her eyes for a moment, as if to defuse her feelings. "He was so mistaken. *Brown Girl, Brownstones* is a kind of classic American novel. It's a novel of immigrants, problems of adjustment and acculturation and so on; it was just that in this case the immigrants happened to be Black. It was also typically American in that it's the story of a young woman coming of age—a rite of passage. It is *supremely* a part of American letters!"

Marshall's life has been riddled with racist insults, and anger and defiance about them figure largely in her books. But her major aim

as a writer is not so much to "take yuh mouth and make a gun," as the women in her kitchen used to say, as to capture the lives of the people she knows and show them in all their humanity.

"There is a kind of thinking current in this society that Blacks spend 24 hours a day reacting to the institutionalized racism of America, that we're totally defined by racism," she says carefully, now fanning herself with a palm fan, now picking at the white fur draped over the back of her couch. "I didn't want to give that impression in *Brown Girl, Brownstones.* I wanted to deal first of all with Selina simply growing up and the kinds of struggles with her parents, with her background, with her trying to deal with her sexuality—I wanted these things to figure in her life before that whole question of racism.

"So first of all, I want my work to reveal the Black people and the Black community to themselves, to itself, so that young Black people going to the library, as I did when I was little, would not have my experience, which was that there were no books about *me*. I want them to see themselves reflected through the fiction and stories just because there's something marvelous and magical when that happens. It gives them a sense of their right to *be* in this world." Marshall paused again, thinking, still and serious.

"The other thing is that, although, like most writers, I write what I know, I am also involved with universal themes, so I hope that the work will give that larger audience, those who are non-Black, the sense of other worlds, other peoples and what the similarities and differences are. And that through the understanding of the humanity of that world, they will be influenced to be better people...

"One of the gratifying things about my work is that, so far, it has done that," she went on, relaxing now into a smile. "Black people go to it and they say, 'You know, that's for real. The same thing happened to me. I *know* that person!' There's nothing more gratifying for a writer! And, at the same time, I get people who are not of my background, who can empathize with the story because it does strike this universal chord. With Selina—yes, she is a young Black woman growing up in Brooklyn, but her struggles with her mother and her determination to be her own person are universal. And with *Praisesong for the Widow,* people say to me they know Avey's struggles to do something meaningful with her life now that she has attained the so-called American success story."

Marshall recrosses her legs and adjusts her simple red sun dress. "And that's been for me what the goal of the work is all about." And with that, she nods her head slightly and makes a little sound of triumph, "Um, hm!"

Helen Rodriguez-Trias

Helen Rodriguez-Trias:
Mixing Pediatrics with Politics

Marie Doherty

by Helen Benedict

> *After I got the job as head of Pediatrics at Lincoln Hospital in the South Bronx in 1970, the* New York Times *ran articles for three days about the Lincoln crisis and how this wonderful pediatrician had been ousted and some incompetent Puerto Rican dame who couldn't speak English was put in—that was me! But I was so busy running that service that I couldn't pay attention. It was a very difficult service to run, and it was the first time I'd done it. It was hot and heavy. There wasn't a single moment without a kid coming in who had fallen out of a window, been run over by a truck, gotten burnt to a crisp in a fire, injested his aunt's methadone and overdosed—it was just incredible. So I was working furiously, trying to hold it all together.*
>
> *Then there was also a state of war going on between the doctors—who were nearly all male—and the nurses—who were nearly all Black and had come up the hard way. The doctors were coming to me and saying, "Your nurses don't hop to it." And the nurses were coming to me and saying, "Your doctors are going around with dirty feet." So one day, out of sheer exhaustion, I said, "OK, I'm walking out. You talk to each other." They nearly killed each other, but they came out compromising. I did a lot of things by instinct!*
>
> —Dr. Helen Rodriguez-Trias, 1984

The first surprise on meeting Dr. Helen Rodriguez-Trias is her youthfulness. She is 55 but looks 35, and that is no exaggeration. Somehow, one doesn't expect an eminent doctor and hospital director to seem so young and casual; one expects age and a certain stiff formality. She bounces about, a veritable dynamo, with the grace of an athlete (she rides a bicycle around New York and skis and hikes for relaxation), laughs often and with gusto and isn't above wearing silly T-shirts: she had on a light blue one inscribed with the words, THE WEST SIDE IS THE BEST SIDE. She is also beautiful, with a small, compact figure and an unlined face: smooth cheeks, high cheekbones and a square, firm jaw. She wears huge glasses that suit her face well, enlarging her eyes and emphasizing the symmetry of her features. Her hair is short but fluffed out, not in the least severe, and her skin is a light, golden brown. The slightest touch of pink lipstick is her only visible make-up. Had she grown up less purposeful and less political, she could have been a model.

After greeting me with a friendliness that immediately put me at ease, she led me into the dining room of her apartment. She lives in one of those vast, stately West End Avenue residences, a peaceful haven from the crowded, noisy streets of the Manhattan summer. The living room seemed to stretch on forever, and the plants cluttering her window sills lent a cool, green cast to the otherwise hot and steamy day. She

bought the apartment, she later told me, with settlement money she won after a bad accident in 1974.

"This home typifies what New York means to me, in a way," she said later. "For nearly ten years, I wouldn't sign for more than a two-year lease because I kept telling myself I was on my way to California. Then, when I got the money and decided to buy a co-op, I realized that I was admitting to myself that I was a New Yorker, invested in the life of New York, that I have friends all over the city, that I'm politically active here, that I get recognition here, and that I'm part of the Puerto Rican community here that keeps me warm, and that it is home. And so I've been here for five years, and I think I'm here to stay!"

After settling us in the living room, with a fan blowing directly on us and all unnecessary lights turned off, she explained to me that she was squeezing this interview between her day at work and a meeting to be held in her apartment of people who want to set up a cancer hospital in Nicaragua. This is typical for her, dividing her time between her job as Associate Director of Pediatrics for Primary Care at St. Luke's-Roosevelt Hospital in New York and her political concerns.

"I like my work and I think it's important," she explained, "but I just don't think it's the universe. When I was directing Pediatrics at Lincoln Hospital between 1970 and '74, I thought I was harmonizing my political work with my day-to-day work. I don't feel this today. Now I have to work outside to move the system a little bit more. So, I hold myself a little corner of energy to do things that I believe in, like supporting the Nicaraguan people in their efforts toward a decent life, and getting involved with the Victim Services Agency in what they're doing with sexual abuse."

With that "little corner of energy," Rodriguez has accomplished an astonishing amount. She helped create a women's health movement that provided alternatives to the traditional, male-dominated ways of practicing medicine. She was one of the first to expose and fight sterilization abuse—the sterilization of minority women in this country and elsewhere without their informed consent. She has fought on behalf of women's rights, the rights of minorities and the rights of children. And she is now working against child abuse. It would be hard to believe how much she has done in addition to her dazzling career if she weren't so obviously full of irrepressible energy.

As Rodriguez laughingly said of herself, "I can't be happy with leaving things the way they are. If I see something broken, I want to fix it. I'm a fixer!"

The urge to "move the system a little bit more"—the political side of Rodriguez that is so important to her—was born, in a sense, during her childhood in Puerto Rico, where she lived up to the age of ten.

"I was very conscious of extreme poverty in Puerto Rico when I grew up there in the 1930s," she said. "Children are very sensitive and really are shocked when they see things that don't look right to them. I saw children and older people begging in the streets. I sort of identified with them." Even though she wasn't so poor—she had a home and a family and went to a private Catholic school—she nevertheless learned some of the bitterness of poverty because most of her schoolmates were better off than she. She still remembers the embarrassment of having to wear her uniform let down at the hem, with the dark strip showing beneath the faded skirt, while the other children had new uniforms every semester.

I asked her if this early awareness of class differences was connected to her eventual wish to become a doctor.

"Well, I think it did have something to do with my perception of the world as needing healing, yes," she answered. "But I was also good at science in high school, and I liked it. It was pretty clear that I was going into a scientific field, and I wanted something to do with people, so medicine seemed to fit."

Yet, even her talent in the sciences brought her face to face with injustices, not only because science was not considered a girl's field, but because it certainly wasn't considered a field for minorities.

"The sciences have not been natural for minorities," Rodriguez said intently. "They [the sciences] come from somewhere else. And, furthermore, they have been prohibited to us. It's like why the American Blacks don't play hand-drums—there were strict laws in times of slavery against hand-drums so they couldn't communicate with each other and organize. And it's true, they don't play hand-drums to this day. It's the Caribbean and South and Central American Blacks who have kept their African heritage. So it is with the sciences. Science is a class thing, science is a power thing, so no 'hand-drums' permitted!" She paused for emphasis, then added vehemently, "But if we don't get into technology, don't get into the sciences, we're not going to come out from under!"

Rodriguez experienced some of this prejudice first hand after she came to New York's Washington Heights at the age of ten. In George Washington High School, she had a chemistry teacher who "would make fun of us. He could never pronounce Rodriguez or the other Puerto Rican names. The classroom was crowded and people had school bags in the aisles, so when he called you from the back to come up to the board, you had to pick your way carefully over the bags, trying not to trip. And he'd start singing, 'Mañana, mañana is good enough for me.' So, by the time you got to the front, you were destroyed. I never got to understand any chemistry that year."

Luckily, she had other teachers who made up for this. She studied chemistry on her own over the summer and came to an excellent understanding of it, and later on, as one of the only two girls in a physics class, she become one of the top students. Her teacher was impressed and encouraging.

From the age of ten up through high school, Rodriguez and her family lived in upper Manhattan at various addresses from 142nd Street to 179th. But when she was ready for college, her mother urged her to return to Puerto Rico.

"She was very, very identified with Puerto Rico and felt that it was kind of a loss to grow up without that heritage," Rodriguez explained. "So, she tried to keep me speaking Spanish throughout my childhood, and she urged me to go back. I think she was very wise about that."

That year in Puerto Rico turned out not only to awaken Rodriguez's identification with her people, but to awaken her to politics in general.

"It was a very interesting year," she said eagerly, sitting up and beginning to talk fast. "Puerto Rico was in a kind of transitional phase, moving from the backward government of the 1930s to a progressive, Social Democrat one. At the same time, there was a resurgence of independent feeling and movement. There was a big student strike, and I got involved in all that."

At this point, her politics began to compete with her career and eventually politics took over. She left college, returned to the United States and worked as a campaigner for Henry Wallace's Progressive Party, a third political party of the time. She also met and married a union organizer and had three children in quick succession. Subtly, this experience began to steer her toward feminism.

"The marriage was a very isolating experience for me. The man was a perfectly good man—he still is—but he was also quite young and very much self-involved," she said a little sadly. "He was also very involved with what he was doing, so he was out all the time. I was alone with the three kids, ironing his work clothes, waiting up all night for him—that kind of thing."

She was also isolated by the circumstances, for they were in Lorain, Ohio to organize the thousand Puerto Rican workers who had come there to work in the steel mills. Lorain was not a cosmopolitan town.

"There were signs up on houses that said, 'NO SPICS, NO HILL-BILLIES, NO NIGGERS, NO DOGS,' so it was impossible to rent a place. And people would say to me, 'Oh, you must be Spanish. You're much too pretty to be a Puerto Rican.'" Being asked to move from the house they were living in because they made friends with a Black

dentist and his wife was the last straw for her and her husband. "We were literally dispossessed because of that," Rodriguez said, still sounding shocked.

Not quite realizing how oppressed she felt by all this, Rodriguez took her children and went back to Puerto Rico for a "vacation," as she told herself and her husband. She never went back to him.

"I could never have done that without my mother because I had no earning power at the time," she said ruefully.

Her mother helped in more subtle ways too, by providing an example of a strong, independent woman with a love of learning. She had begun work as a school teacher at only 14 years old, when the family lost its coffee farm in the takeover of Puerto Rico by the United States and its corporations. She continued to teach with pleasure all her life.

"My mother was an active person. In Spanish they call it *emprendedora*—somebody who undertakes things, who has initiative. At a time when women were totally subjugated by men, she got divorced, and she was the one who was out there, making the money, trying to get my brother a scholarship, making sure he stayed in college, that sort of thing. So I identified with the sense of women being out there, doing things, being strong, and having to be."

Having discovered that being a wife and mother was not enough for her, Rodriguez became determined to do what she had wanted to do all along—go back to college. When she met the man she was to marry in Puerto Rico, she made sure he understood that she wanted to go to medical school. She married him, went back to school and had a fourth child during her medical internship. That was, she says now looking back, the hardest time of her career.

"I think my children were neglected for the three years I was an intern," she said with a sad smile. "I didn't have enough energy to pay attention to what was going on or to listen to them or be very nurturing, especially because my fourth child was born then and he, as a baby, had to get a lot of attention. And I think they resented me because of it."

I asked her if she felt guilty about this neglect.

"Oh yes," she replied frankly. "I think one of the things that kept me going back and forth between being focused on what I was doing at work and them at home was that feeling of guilt that I had gratified myself but maybe not done what I could for them.

"You see, I was socialized to be subservient to men. Yes, it was all right to go out and get good grades, to study and get a career, but at the same time you weren't worth much if you weren't married and keeping your husband happy. So part of that was in the way I viewed my role in marriage and even my role as a parent.

"Still," she added thoughtfully, "I think all we working mothers feel inadequate on various levels. Not that non-working mothers feel any better!" She flung back her head and laughed! "At least we have some areas of competency to fall back on! What if your children blame you and all you did was spend your whole life taking care of them?" And she laughed even louder.

After qualifying as a doctor from the University of Puerto Rico School of Medicine at the age of 31, Rodriguez spent the next eight years in Puerto Rico, first as a general physician and then as a neonatologist (someone who specializes in newborns), directing the newborn service at the National Institute of Child Health and Human Development in San Juan. During this period, her interest in politics was receding somewhat, for she was in a comfortable and highly respectable position. But something inside her told her that she was still not satisfied, that she needed more of a challenge. In 1970, after a second divorce, she decided to leave the safe but narrow life she had built in Puerto Rico and return to the United States.

She had planned to go to California to get a degree in public health because she was beginning to believe that many health problems could only be solved by going into the community, not just by treating people at hospitals, but she was detoured by a tempting offer. Lincoln Hospital in the South Bronx needed someone to head Pediatrics. She was offered the job and, unable to resist such an important position, she accepted.

Her job at Lincoln turned out to be the most difficult and challenging work she'd ever done. Even now, ten years after she resigned from that position, she talks about it with passion and a touch of nostalgia, for at Lincoln she became caught up in a medical revolution—the introduction of patient and community participation in health care. At Lincoln, she learned to question and change the traditional patriarchal method of practicing medicine—the big, white doctor in the big, white coat who tells you what to do as if you were a child. But coming to this position was, at times, painful, even for someone as radical as Rodriguez, for it was not easy to shake off her training to think of doctors as superior beings who always know best. In a lecture she gave at Barnard College in 1976, she told the story of her first encounter with the American health care system as a patient. It was an experience in which she "was the unwitting control subject in an experiment involving 'primaparas [women with first pregnancies] with and without emotional support.' I was the 'without,'...."

This cruel experiment left her with a special feeling for the "victims" of health care.

"My awareness grew out of reality," she had said in her lecture. "I knew all along that, despite my diploma and the status it partly con-

ferred, I was of the same flesh as the women who screamed during a delivery without anesthesia. I believe that this sense of deep communion with women as patients somehow kept alive in me the humanity I now try to nurture..."

It took nearly ten years, exposure to racism toward Puerto Ricans in this country and exposure to the women's movement of the 1960s for Rodriguez finally to put the patchwork of her experiences—her feminism, her politics, her patriotism, her humaneness and her medicine—together into a coherent whole. The result has culminated in the type of person one would wish dominated all of medical practice. She endorses and encourages alternative health care systems. She believes patients should know and understand what is being done to them and, more important, should have a say in it. She teaches medical students a humanitarian approach to their craft, and has created teaching programs to encourage this. And she has struggled to end racial prejudice both in and outside of medicine. What else, I asked her, would she like to accomplish?

"More than anything else, I want more time," she replied wistfully. "I want to do more women's work, more direct services for women, such as counseling, more work with women on parenting, on sexual abuse. And I would like to have more of an impact on the medical education process, and to concentrate on minority groups and their sense of power and fear of the sciences..." she trailed off, as if overwhelmed by all that she would do. How, I interrupted her, would she like to be thought of after she had done all that?

"Oh," she said in a quiet, quizzical voice, "as someone who—in a small way—maybe left things in a little better shape than she found them."

Yolanda Sanchez

Yolanda Sanchez:
A New York Activist with a World View

Marie Doherty

by Jacqueline Paris-Chitanvis

> *Some of my best friends are men who cook better than I do. Role reversals are good. With less sex role stereotyping, we are much more open, and I think that we wind up being better human beings for it. Yes, there are things that only men can do, and things that only women can do. But there are very few of those things. Most of everything else—99% of everything else—both men and women can do. A man can take care of a baby as well as I can. And we should share that responsibility. I think it is happening... very slowly, but it is happening. I wish I could sort of turn a crank, like the way you do a fast-forward on a tape recorder or a VCR, but there is no such thing in life, so you have to let it play out and do it at its own pace—moving slowly but surely forward.*
>
> —Yolanda Sanchez, 1984

In 1975, Yolanda Sanchez announced that she would run for the New York City Council representing the heavily Hispanic district that encompasses East Harlem and parts of the South Bronx and Queens.

"I declared my candidacy that January," she says, "because I was fairly well known in the district, had credibility and the people respected me. I had done a lot of things in the community, was able to raise money and I had volunteers."

But just four months after the social worker and community activist publicly declared, her campaign encountered unexpected opposition—a Puerto Rican man decided to run for the same seat. "We called a meeting because it was obvious that with two Puerto Ricans running we would divide our community and our people, and the person who held the seat would win," explains Sanchez. "When we met I remember clearly that I said, 'Here are the reasons I should run: I have a track record, I'm respected, I can raise money. I declared in January, and here it is four months later. Why are you doing this to split the vote?' Do you know what his answer was? 'You should withdraw because you're a woman.' Well, that's the *last* reason anyone should give me for doing something," she says with an edge of defiance in her voice.

Both candidates stayed in the race. Both lost.

Despite the loss, running for public office was, in many ways, a victory for Sanchez. Born in Harlem Hospital in the early 1930s, Yolanda was the fourth of six children born to Ana and Candelaro Sanchez, Puerto Rican immigrants who came to the United States in the late 1920s. "We were poor as church mice," she says. "Sometimes I look back and say, 'My God, the little Puerto Rican girl who started out on welfare, look where she wound up.'"

An introverted child, Sanchez went through public school largely unnoticed. "I was very shy. The type of person who would sit there and

not ask questions. My brain must have been working, but I was not asking questions. And I certainly wasn't challenging the teachers for information."

With no specific goals in mind, Sanchez graduated from high school and enrolled in college. "I am a real New Yorker in that I took advantage of all the public school systems," she notes. "I went to City College when it was a free municipal college and I am grateful for that. I was sorry when they started charging tuition because I think part of the value of being a New Yorker was that you had the chance to go on and be educated."

An elementary education major in college, she initially planned on becoming a school teacher. "But I was constantly told [by people in the college] that I would never pass the board of examiners [for teaching certification] because I spoke too fast," says Sanchez. Another thing she was told—which astonished her, since she was born and raised in New York and could not hear it herself—was that she wouldn't pass because she had an accent. "I was intimidated," she recalls, "so I took an equal number of credits in sociology."

After graduating, Sanchez "followed the crowd" and went to work for the New York City Department of Social Services, as what was then called a social investigator. Though unplanned, a successful career was set into motion.

Sanchez was with the Department of Social Services until 1962, when she left to work for ASPIRA. Two years later she was named its program director. During this time she enrolled in a master's program in social work at Columbia University and received her degree in 1966. From 1966 to 1968, she was the coordinator of the community development and services division of the Bedford-Stuyvesant Community Corporation in Brooklyn. In 1971, she joined the staff of City College as the director of the office of Puerto Rican program development. Since leaving City College in 1976, Sanchez has served as project director of the Puerto Rican Association for Community Affairs and as executive director of the East Harlem Council for Human Services, Inc. She currently works as a free-lance human services consultant.

Her work day now varies, depending on where she is consulting. But a normal day for Sanchez on her last full-time job as director of the Boriken Neighborhood Health Center (part of the East Harlem Council for Human Services) consisted of long hours and almost nonstop work. "My day started at 9 A.M., and I usually didn't leave before 7 or 7:30. On a typical day there was always mail to read from the government or the agencies that gave the money to run the programs. There were conferences, discussions with the staff and general supervision. I may or may not have gone out for lunch, depending on what had to be done. After lunch, more reading, more meetings, more decisions. One

of the reasons I often would stay late was because of the many interruptions during the day. I would find that by staying late in the evenings for an hour or two I could catch up with the reading I had to do for the job as well as answer letters and write reports."

Good as she is at what she does, Sanchez did not set out to become a community activist or even a social worker. "I love my life," she says without hesitation. "But there was no prethought to a career choice. I probably could have been a good lawyer. But I didn't become a lawyer because it never occurred to me that I could. Who thought of those things for a young Puerto Rican woman 30 years ago? Not once in my life did anyone say, 'These are your ten options. Do you want to be a lawyer, do you want to be a doctor, do you want to be this or that?' It was just assumed that I was going to be a teacher [the usual choice of minority women at that time]. So, I floated.

"My parents were poor, they didn't know college from a hole in the wall. They couldn't give me that kind of guidance. I think many kids still suffer from this. They might get encouragement to go on to college, but they may not get help in clarifying their thoughts and focusing on what career they are going to follow. This is why it is so important to have good counseling in schools. It is not that our parents don't want to do it. They often are not capable of doing it because of their own backgrounds."

Today, Sanchez is a far cry from the shy little girl who never spoke up in class, or the uncertain college student who drifted into social work. Youthful, energetic and outspoken, she is a woman who channels much of her time into improving the plight of New York's Puerto Rican community, especially its female population. She firmly believes that these women must begin to take more control of their own lives. In an effort to get more Puerto Rican women involved in political, economic and community concerns, Sanchez helped establish two organizations: the New York chapter of the National Conference of Puerto Rican Women in 1972 and, in 1983, the National Puerto Rican Women's Caucus. Although no longer active in the former, ("they weren't feminist enough or aggressive enough on issues," she says), Sanchez is very much involved with the Women's Caucus. "This particular group is an attempt to organize Puerto Rican women who have reached a certain level of education and a certain level of development in their professional lives." The aim of the organization is to make them aware of economic development, according to Sanchez, to get them involved not only in the political process but in the money-making process as well. For instance, the Caucus teaches Puerto Rican women how to take the income that they earn and make it work for them—through single or joint investing, by starting a small business. The group also works to make women more aware of their abilities and potential.

"I think we have a long way to go, not only as Americans, but specifically within the Puerto Rican community, before we really accept women as equals," she says. "I want people to relate to me as a person who has intelligence, or who speaks well, or who has ambition. We are far away from that. But every day we are moving forward, so that tomorrow it will be a little bit better than it is today."

As the mother of a college student, Sanchez is looking forward to that better tomorrow. "I want my daughter to feel that she has options that I didn't have as a Puerto Rican woman. If she says I want to be a brick layer, she can go off and be a brick layer. If she says I want to be a doctor, I want her to feel that there is an opportunity, that it is up to her."

By adopting her when she was 17 years old and giving her a secure family life, Sanchez helped make it easier for her daughter, Luz Celeste, to take advantage of the many new possibilities available to women. Many people would have balked at the idea of taking on the responsibility of caring for a teenager, but Sanchez talks about her decision as though it were a run-of-the-mill thing. "The child was in foster care at the time, and her foster-care agency was looking for new parents," says Sanchez. "She had met me through someone on my staff at City College who knew her from Puerto Rico. She asked her foster-care agency if they would contact me to see if I would take her. I thought it over, talked to my staff member who knew the child's family and agreed to do it."

As a single career woman (she never married) suddenly thrust into the role of mother, Sanchez had to make some major changes. "Here was a child that needed a lot of attention. I had to adjust my life style, since I previously had no responsibilities in that sense. I used to be able to attend almost any evening meeting I wanted to. I could go to the theatre with friends, I could go out to dinner. I didn't have to come home. But once you have a child—I don't care what age—there's a responsibility to that person."

According to Sanchez, that responsibility includes making the world a safer place for her daughter to live. "The latest thing I'm involved in is the National Conference to Avoid Nuclear Warfare [a conference of women working to promote peace], because I think very seriously that this country is on a track leading us to war. And I don't care if it is a small war in Nicaragua or a major war with nuclear arms."

Sanchez believes that her daughter and other young people also have a responsibility to make the world a better place. "I want my daughter to understand that there is a role she or any person can play to make their government stop leaning toward war and bring us back to a

peaceful era. I think all of us can do a little bit. Whether it is working three hours a week on a political campaign or working with a community group. I don't have to be the president of the United States or the head of the UN to work for peace."

Constantly on the go, Sanchez finds little time to relax, but when she does she likes to do it in her city. She has lived in the Bronx since 1979 and often visits members of her family—two sisters live near her—or stays at home and watches television." There are certain things I watch out for, especially on Channel 13 [public television]. The latest one, for instance, is a series on Viet Nam. I opposed the war and I knew why. But it is fascinating to see and understand the real history of Viet Nam," she says.

Sanchez also is an aficionado of the theatre. "I belong to several organizations that tell me what is on Broadway," she says. "But more important to me, I belong to things like the Caribbean Cultural Center. They will send notices about programs, such as those that show the African influence on many parts of the Caribbean or Latin America." Reflecting for a moment, she adds, "It's interesting that my forms of relaxation tend to teach me more about myself."

In order to learn more about herself, Sanchez feels that she also must learn more about people in other parts of the world. And despite the diverse cultural experience that New York provides, she thinks learning first hand is best. Acting on this belief, she led a group of New Yorkers to China in 1976. The idea for the trip began germinating in 1972 when President Richard Nixon normalized relations with the People's Republic of China and made a visit. "It occurred to me," she says, "that it was fine that the president of the United States visited China, but why shouldn't I, Yolanda Sanchez, visit China and perhaps visit it with some other friends who are doing things in this city? And that is exactly what happened."

Sanchez put together a group of East Harlem activists, people who either worked or lived in the area and who were interested in visiting China. The group held seminars and workshops to learn about China and its culture before they left on the tour. "We were there 18 days, and it was marvelous," she says. "The government over there works out a tour for you. We told them the type of things that we were interested in. For example, one of the people with us was a doctor who worked at a neighborhood health center, so he was interested in finding out something about the health care for the Chinese people. I was interested in how women are treated in China. We saw cities, we saw farms, we saw rural areas, we talked to people who were health practitioners and things like that."

More recently, Sanchez visited Nicaragua (in March 1984) with a group of North American women of all ages, races and religions who

were delivering food (milk and cereal) donated for the country's needy children. "We timed the visit so that we were there for International Women's Day [March 8]," she explains, "so the trip was focused around our being women. We were met as a woman's delegation by the Federation of Women of Nicaragua and they took us on a tour—visiting farms, rural settings, large cities. Since I speak Spanish, I could talk with the people on the street. We also were able to visit with some of the government ministers."

Trips, such as the ones she has taken, are important for giving Americans a more rounded view of the world, according to Sanchez. "If we are not careful, we can tend to see America as the whole world and think that whatever we do as Americans is the right thing," she says. "But all of us can do wrong. We have to understand other people and other countries."

How does she want to be remembered? "I would hope that I was a person who was respected," she says without hesitating. "I tend to respect people, and I would hope that people respected me—not that I did everything right, but that I did things that I thought were right. I also hope that people will remember me as a person who cared for her community, who cared for people and who attempted to use her life and her energies to improve conditions."

Muriel Siebert

Muriel Siebert:
Playing the Numbers on Wall Street

Marie Doherty

by Roslyn Lacks

> *One rainy, dreary, cold New York day I hailed a taxi, got in, and sat back in the cab, bemoaning my rain-soaked fate. When I arrived at my destination, the driver cheerfully gave me my change and wished me a good day. "It's a lousy day," I snapped back. "Lady," said the cabbie, who had been fighting his way through city traffic since early morning, "there's no such thing as a lousy day." I've never forgotten that incident, and from that moment on I have tried to maintain the positive outlook of that wise cab driver.*
>
> — *Muriel Siebert, 1984*

Black glass and chrome, the elegantly appointed skyscraper on Water Street in New York City's newly developed South Street Seaport area stands midway between the East River and Wall Street, which threads its way uphill into the City's financial district. Elevator doors on the fifteenth floor open directly to the offices of Muriel Siebert's discount brokerage firm.

Framed photographs and documents line the walls of inner and outer offices, punctuating the considerable achievements of Siebert's career. Among them: awards and honorary doctorates; a reproduction of the front page of the *New York Times* in December of 1967, when Siebert made history by becoming the first woman to hold a seat on the New York Stock Exchange; and copies of the proliferation of articles that appeared about her when former Governor Hugh Carey appointed her Superintendent of New York State's banking system in 1977.

Her private corner office is sunlit and spacious; plants flourish in windows that overlook spectacular views of the harbor. A round lucite table serves as a small conference center. Today, it holds a smattering of papers, topped by a photograph that has not yet been mounted: Siebert, small, blond, and compact, with President Ronald Reagan at a meeting of leading businesswomen, shortly before the 1984 presidential election.

"You know, they never let us get around to asking him questions," she remarks with a trace of indignation.

What questions would she have liked to ask?

"I was prepared to ask him about the deficit," she declares, eyes flashing as she returns to her desk to take a phone call.

Her own desk is piled high with papers. From time to time, her slightly tilted blue-green eyes, looking over half reading glasses, dart from notes on her desk to phone lights to a computer screen that registers the ongoing course of the day's market, then turn to you

with a startling intensity, conveying a sense of enormous controlled energy. She is wearing a gray box-jacketed suit with a thin white stripe running through it and a bright red blouse. The red is her earmark, the splash of color she brings to the traditional muted grays of Wall Street.

Born in Cleveland, the younger of two daughters of a dentist who "died broke" while she was still in college, and a mother who had a real estate broker's license but whose real love was painting, Siebert scarcely anticipated her future impact on Wall Street during her growing years. She herself played the clarinet, and a love of music still sustains her.

"When I'm working at home," she says, "music is always on. I find it washes all the day's cares away."

She plays tennis and golf when she has time, but time is a scant commodity for Muriel Siebert these days. She took up solo flying some years ago, but gave it up when she became Superintendent of Banks, hoping one day to resume it. In addition to reorganizing her firm, she is the 1984 chairperson of the Boy Scouts of America and a staunch advocate of its job training project for high school dropouts. Among Siebert's many speaking engagements are regular appearances at women's programs at the Lexington Avenue YWCA. On those occasions, she never misses an opportunity to announce that she would like to rename the "Y"—"'You Women Can Accomplish' is what I think those letters really stand for," she always tells them.

"I'm really overstretched," she comments. "It makes me angry that I don't have more time. Life was less harried growing up in Cleveland, but "once you've come to New York," says Siebert, "you can't go home again."

She came to New York in 1954 with a Studebaker and $500 in savings and the idea of getting a temporary job. She had been in New York only once before, visiting a cousin who worked for the United Nations. Her memory of the two most exciting places during that visit were the UN and the balcony that looked down on the trading floor of the New York Stock Exchange.

She first tried for a job at the UN. When that didn't work out, Siebert turned to Wall Street. "What if she had gotten the UN job?" an interviewer asked her. "I probably would have had fallen arches and might have been the chief messenger girl by now," Siebert replied.

Merrill Lynch was her first stop on Wall Street, Siebert recalls. "When they said, 'College degree?,' I said no; so no job. I went to Bache the next day. When they said 'College degree?,' I said yes, so

they hired me. Bache & Company offered a choice: a back-office job in accounting for $75 a week or placement in training and research at $65. Siebert opted for the lower-paying research job. Thirteen years later, she was clearing half a million dollars a year, researching and trading stocks.

"You could get by on $65 a week, then," she contends, adding wrily, "Today, I pay more to garage my car than I paid for apartments for years."

Her first research assignment at Bache was to write reports about industries with growth potential in order to create interest and stimulate sales. Two of her topics—airlines and the sale of movie rights to television—were then considered duds. "The senior analyst thought airlines would never go anywhere," she recalls with a smile. "It was luck. I could've gotten industries without any public appeal."

But Siebert's capacity for "letting numbers speak to her"—her faculty for perceiving and predicting financial trends—stood her in good stead. By the time she had completed researching the airlines industry, she was considered something of an aviation expert and began to get job offers from aircraft corporations. She assisted in an airlines consulting project and served on the buying side of an investment fund before moving on to Shields & Co. in 1958.

At Shields, she was still on a research payroll, but gained greater control over which industries she would research. On the basis of some of her early reports at Shields, clients approached her, wanting to buy stocks from her. Siebert was not registered to sell stock, but not for long. She obtained a license from the New York Stock Exchange that enabled her to sell stock under Shields's auspices. Stock sale commissions soon amply supplemented her base salary of $9,500.

"When I started to call on institutions," Siebert points out, "I only recommended stocks that I had personally researched." Buyers found the approach of a "selling analyst" more appealing than that of a broker out to make a fast commission. Indeed, Siebert credits her research background for her success in bringing new institutions into the firm.

But the time had come to move on. Partnership was the next step. Women partners on Wall Street were a rare phenomenon, indeed— just the sort of challenge that would spark Siebert's determination. In 1960, she became one of Wall Street's first women partners at a smaller company, Stearns & Co. She talked to traders on the exchange and learned how to handle big block and multiple stock orders. Over the course of the next seven years, she built up a mammoth commission business.

Early in 1967, a friend and client suggested to Siebert that she buy a seat on the New York Stock Exchange. Not one of the Exchange's 1366 seats had ever been held by a woman. Yet Siebert could find no stipulation in the Exchange's constitution that barred a woman from joining it. Still, the road to buying the $445,000 seat on the Exchange proved bumpy. Brokers on the floor refused to sponsor her. Unlike men applying for seats, she had to present a letter from a bank guaranteeing that she would get a loan if she was accepted. ("It gives me great pleasure," she told a conference for women in business some 14 years later when she was Superintendent of Banks, "that I now regulate the bank that refused my loan application.")

"Once they said the Stock Exchange couldn't admit women because the language on the floor was too rough; they said it was no place for women because there were no ladies' rooms on the main floor. Those arguments sound antique today," Siebert notes, "but they were made less than 20 years ago."

On December 28, 1967, her bid of $445,000 was accepted, and Muriel Siebert became the first woman in history to own a seat on the New York Stock Exchange.

Newspaper stories about her purchase of the seat referred to her as a "petite blonde," and "the girl from Cleveland." Said one headline: "Now the Girls Want to Play, Too."

For nine years, Siebert remained the only woman on the Exchange. "I was delightfully outnumbered," she remarks, "1365 men and me." She grins. "Those are pretty good odds. But it can be tough too," she adds. "There were all kinds of reactions. Not everybody loves you when you break a tradition. Some people were hostile; some were very nice. It works both ways."

"But you didn't give up?," she was asked.

"Oh, no!" Here she is adamant. "I didn't give up. It becomes a challenge. I don't like to give up," she repeats quietly but emphatically; "it becomes a challenge—a personal challenge."

Indeed, feistiness in the face of challenge is a Siebert trademark. After operating for two years as an individual member on the Stock Exchange, she formed Muriel Siebert & Co. in 1969, operating with two people out of a two-room office. (Today, the firm employs over 20.) When commissions became negotiable in May of 1975, she began to give her institutional clients bargain rates, underselling other brokers. In September of 1976, she held a press conference at the "21" Club to announce that she was "going discount to the public"— removing the discrepancy between what institutions with large

blocks of stock and individuals with small holdings had to pay. She sold to all buyers at the same rate, launching an ad campaign that featured pictures of a smiling Muriel Siebert cutting a hundred-dollar bill in half. Some of her colleagues cut her off in return.

In March of 1977, New York's Governor Hugh Carey—a Democrat—queried Muriel Siebert—a registered Republican—about taking over as Superintendent of the state's ailing banking system. Here, she counts herself a recipient of the benefits of the feminist movement. He was looking for a woman, Carey frankly told her, and hers was the only name that kept cropping up. She couldn't say no. "In a situation like that," she observes, "you really can't say, 'Would you mind coming back two years from Tuesday.'"

Following regulations for state officials, Siebert divested herself of any stocks in companies she would now regulate and put her own company into a blind trust. Her jurisdiction over institutions with assets of over $500 billion included more than 103 savings banks, 104 commercial banks, and New York branches or agencies of 139 foreign banks. Her salary started at less than $50,000 a year, moving to slightly more than $60,000 during the five-year course of her tenure.

Siebert took to her new job with characteristic grit and tenacity. Seventy-hour weeks were not uncommon, filled with frantic phone calls and late-night meetings with regulators and bankers. As Superintendent of New York State's banking system, she was responsible for many of the rescue mergers that saved troubled banks from going under.

"Mickie confronted about the worst problems of any state regulator," one bank chairman noted. "And she grabbed the reins. She took the flak."

"Gutsy," is how another industry spokesman put it. "She was the most active bank Superintendent in the country."

What Siebert herself takes most pride in is that during the course of her five years as Superintendent "not one bank failed."

In 1982, Siebert resigned from her government post to run as a candidate for the U.S. Senate in the Republican primary, coming in second in a three-way race. With more business people in government, she suggests, the country would not have run up so large a deficit.

Would she run for political office again?

"Well, I got a problem," she replies. "I'm one of those 'bleeding-heart' Republicans." Although she doesn't believe in voting a

straight party line, she has been critical of the Democratic platform in recent presidential elections and feels the Republicans have moved too far to the right.

Meanwhile, she has been hard at work getting her own firm back into shape. When she returned, she found the firm had lost the institutional half of its clients, as well as most of its personnel. "When I came back here," she declares, "there was not one person who was there when I left. We didn't share in the growth of the industry." Things are very nearly where she wants them now, and she hopes soon to be able to embark on projects she has in mind for the future.

"Some day, I'll write a book called Blind Trusts and Stupid Mistakes," she quips.

The recipient of four honorary doctorates and a frequent speaker at prestigious universities, among them Harvard and Wharton's graduate schools of business, Siebert describes herself as a "college dropout." Her father's long illness and eventual death while she was at Case Western Reserve in Cleveland precluded the possibility of her graduating. "The money just wasn't there. In no way could I continue with college.

"Secondly, oh boy!" she hesitates, turns to the window, toys with her glasses. "How do I say this?" She turns to me candidly. "If I like something, I do very well; if I don't like it, I'm a disaster. So I had some lousy grades in subjects I didn't like. I came out highest on entrance exams, but they would not take me into the great established school of Flora Stone Mather College, which was the women's branch of Western Reserve, until I went down to Cleveland College and proved myself.

"After I got all A's the first semester, they took me into Flora Stone Mather—and I hated it! It was all memorizing. I used to have to go to the men's college to take my courses in business and economics—I was the only woman there. At Cleveland College, we had the business people teaching the courses; they were part-time professors. I found the business courses challenging; numbers would leap off the page and speak to me.

"Anyway, that's the story, but it's a hard story to tell kids in high school. I'm sensitive to the fact that I'm a role model, and I don't want people to say, 'She's a dropout, I can drop out, too.' Times have changed. When I speak at colleges, I say you've got to get your degree because maybe you won't be as lucky as I was, and you won't get your first job..."

Besides, at that time opportunities for student loans and work-study programs simply were not as abundant as they are now, and

given her financial situation, there was no way Siebert could have completed her college education.

Her plans for the future?

"Frankly, I enjoy using my position to help women." She leans forward. "What I'd like to do one day is to have a women's financial counseling service, because they still don't get treated fairly."

Siebert's advocacy of financial savvy for women goes back to her early days on the Stock Exchange when she circulated a survey to find out what kinds of financial courses were available to women in college. "More than two-thirds of the 80% of the women's colleges that responded," Siebert points out, "did not have one course in managing money." Invariably, they argued that finance was "not a proper subject for women.

"So, women have not been taught how to manage money. They don't know investments. When they get divorced, they think they have money; then they turn around and find out five years later that they've gone through it. They haven't been taught the basics," she insists. "Money management should really be taught in high schools."

What kinds of things would be taught?

They are at the tip of her tongue, and she rattles them off: "How much can you afford to pay on a mortgage? How do you build up credit? Why is it important? What are the basic kinds of investments? What is a municipal bond? What tax bracket should you be in before you buy a municipal bond? What is an IRA? A Keogh?

"Most women today are working," she points out, "not from choice, but from necessity. We no longer have an economy in this country where one paycheck is going to cover the basics—the buying of a house, a car, a college education for children.

"Our expectations for the quality of life have gone up," she adds. "Television has shown people the country; they want to see it. They also see how other people live and want it for themselves and for their children. It can't be done on one salary anymore.

"Then there are the divorcees, the widows, and the need to supplement Social Security, especially for young people growing up today. I get letters from women who have been widowed about what they can afford; they just don't know. They need that financial counseling; they're willing to pay for it. It would never be a big profit item. Basically, it's a service. If I could do it on a break-even basis now, I would do it. It's something that's needed."

Despite barriers that still exist, women have made substantial inroads into New York's business and professional communities over the past two decades. Recent legislation mandates that women can no longer be barred from membership in business and professional clubs. Siebert was one of those who testified in 1973 before Commissioner Eleanor Holmes Norton at preliminary hearings of the Human Rights Commission that were integral to the enactment of the new legislation. She still remembers the luncheon club where she had to go through the kitchen to get to a directors' meeting on the second floor.

"A lot of luncheon clubs did not admit women," she recalls. "I was vice-president of a sales executives' club [Joan Crawford was the first woman member; I think I was the second.] I became a director of the club and had to attend a directors' meeting at the Union League Club on 38th Street and Park Avenue. When I walked through the door, they said 'Sorry!' It turned out that I had to go through the kitchen to get to the meeting on the second floor. I sat in the meeting, getting angrier and angrier; I had no idea what was going on at that meeting; it was as though I were a million miles away. Three men who were there offered to escort me from it, but I wasn't allowed on the elevator. They ended up walking through the kitchen with me." She laughs. "It was so stupid!

"But things are changing," she adds. "When I started out in the Financial Women's Association, they were mostly secretaries. Now they're vice-presidents of banks and insurance companies. There's a great world out there!"

What kind of jobs are available for women in the financial world today?

"There are so many," she replies, "securities analysis, sales, financial counseling, back-office jobs like accounting, where people make good money. Institutions are changing," she observes. "We're going to see more one-stop financial shopping, a kind of financial supermarket where people take care of their bank accounts, mortgages, and investments in one major institution. When industries change," Siebert notes, "new opportunities emerge—opportunities that people who have been in the industry for a while don't even sense. They may have been trained one way and find they can't adapt. In certain respects, I'm outmoded," she adds. "New financial products, financial futures—that's a young person's game."

And New York City, of course, remains the foremost arena for playing out that game.

"When you've been in New York," suggests Siebert, "you can't go home again. New York is the place to be. It's the hub of banking, the

center of world finance. You can move ahead here. New York is a spot where you can learn, and when you can learn, there's always an opportunity to advance. Part of it is the availability of courses. If you're in one aspect of business and find you don't like it, you can train for another aspect. You can't do that in most cities, but you can here. That's why I say New York is the best!"

"Kiss," says Siebert when asked about the best advice she has ever given or received.

Kiss?

"KISS," she repeats, breaking into a grin. "You know what it stands for when you give a speech? 'Keep It Short, Stupid' or 'Keep It Simple, Stupid!'" She laughs.

"The meaning of success," she adds, "is not measured by money. Wall Street happens to be a place where if you're a success, you make money; but other fields have different rewards. People generally do well what they like. Of course, you have to meet things halfway. When you get knocked down, just get up and start all over again. But"—and this is clearly the credo by which Muriel Siebert lives her own life—"set your goals high. Don't let anybody tell you 'no.'"

Beverly Sills

Beverly Sills:
Undaunted and Undefeated

by Helen Benedict

I once walked on the beach with Mrs. Kennedy. It was after both her boys had been murdered and I said to her, "I just don't know how you've stood what you have." And she said, "Well, I think that sometimes God inflicts the most suffering on the people he loves the most. And every once in a while, I clench my fist and I shake it up to heaven and I say, I won't be defeated!" I've kept that with me a long time.

There's a little plant over there with printing on the pot that says, "I won't be defeated." That plant was one leaf, and I clipped it off a great big thing that was dying and stuck it in the ground. This whole office got hysterical because, as you can see, we're underground—we have no windows, no light. They all laughed at me. Look at the size of that plant now. I think you have to take everything that looks like a blow and turn it into a triumph. This is where my energy comes from: I just won't be licked.

—Beverly Sills, 1984

The powerful will and self-confidence that this story reveals is apparent immediately upon meeting Beverly Sills. Tall and solid, she gives off the air of being utterly unshakable—not a nervous giggle or fidget to be seen. She is calm, stately, large and even a trifle stern, in spite of a curly, feminine hairdo and heavy makeup; she is a mixture of queen and mother. But her assurance also makes her easy to be with, and she laughs readily and merrily, her expressive eyebrows arching high above her lively eyes. Indeed, her face changes dramatically with her moods, perhaps a result of her many years performing the melodramas of opera, perhaps a natural talent that added to her acting. When she smiles, her round cheeks bunch up into a happy, girlish grin, which is enhanced by the reddish-blond curls that frame her head. When she is serious—and she often is—the lines circling under those cheeks pull her face down into an expression that is achingly sad. But capability radiates from her every move. She makes you, somehow, want to lay your fate in her hands.

This capability, which she probably possessed ever since the age of three, when she was already winning talent contests and doing radio shows, has been essential to her dual career as singer and opera director. As an opera singer, she has achieved one of the most distinguished careers in the field. She was a leading soprano for both the Metropolitan and New York City Operas and has sung with famous companies throughout the world, thus becoming one of the first Americans to break through the traditional prejudice that only Europeans can sing opera. When she retired from singing in 1980— "I got out while they were still fighting to buy tickets to hear me. I believe in getting out when you're on top, and that's what I did"—she became general director of the New York City Opera.

In that position, Sills has created the first home company for American singers who, up until now, have traditionally gone to Europe for training and experience. She has also embraced new, innovative operas written by young composers and has kept the company predominantly American, unlike the Metropolitan Opera which follows the time-honored practice of importing famous European singers as its stars. She has also worked to get funding and scholarships for young singers, and many in her company are Hispanic, Black or from less-than-wealthy backgrounds.

"I am responsible for everything you see and hear from the minute you walk in here!" she says with a somewhat proud laugh. "I frequently say that I never share blame, I never share credit and I never share desserts!" Then she adds more seriously, "To run an opera company—well, it only advances by crisis. But the buck stops here."

The work of running an opera company makes Sills's days seem "endless," as she puts it. She gets up at 6 A.M. to make breakfast for her husband, Peter Greenough, a retired newspaper executive, and their 25-year-old daughter, Muffy. She goes to her office in Lincoln Center at 8:30 and spends an hour dictating letters and memos. Then she begins an eternal round of fundraising activities, rehearsals, production meetings and decision making. She takes no lunch, unless it's a fundraising event, and if there's a performance she must watch it either in the theatre or on her closed-circuit television, so the day doesn't end until 11 P.M. If there is no performance, she collapses into bed at 9.

"Sometimes, I feel just plain sleepy," she admits.

She tries to get home for dinner, so that she can at least have a couple of hours with her family, but often her husband and daughter have to meet her at Lincoln Center and take her out to dinner. Sometimes her husband brings his books and sits quietly in the office with Sills as she works.

Because she spends so much time at work, Sills has decorated her office to look like a home. It is a surprising sight, for the rest of the "backstage" area of the opera house, which is really underground, has the cold, institutional look of a hospital: corridors of white tile and brown metal lockers in dim electric light. Her living-room-like office is clearly a haven: overstuffed chairs and couches on the thick carpet, knickknacks crowding the coffee table and posters of past operas adorning the walls. On one wall hangs a lush, blue-velvet curtain that sweeps from ceiling to floor. It is embroidered with elaborately bejewelled queens—no doubt representing the many queens Sills has played in her operatic roles.

Beverly Sills did not have the beginnings one might expect of an opera "superstar," as the press has often labeled her. Born Belle Miriam Silverman 55 years ago, she grew up in what was then a typical middle-class Jewish area of Brooklyn—Coney Island. It was a far from affluent neighborhood.

"We only had a radio because my grandfather built us one," she recalls, "and when my father got a car, the whole neighborhood had a ride in it. And we all wore hand-me-downs."

Her father, a Rumanian Jew who came to this country as an infant, was the undisputed head of the household. He laid down the law, paid all the bills and even accompanied his wife when she went clothes shopping. "He thought she was the most beautiful woman he had ever seen," Sills remembers with a laugh. "And he didn't mind telling everyone so!" But, in spite of his old-fashioned values, he encouraged his only daughter to learn as well as his two sons.

"He gave me my sense of discipline," she says, suddenly turning serious. "He didn't have any respect for people who would not finish what they had set out to do. He was also very practical." He made her go to summer camp once, for example, because he wanted her to have interests other than singing, in case that didn't work out for her. "You can't be single-minded about anything," he told her.

When Sills won the Most Distinguished Athlete Award at camp that summer, her father was proud. When she got top grades throughout school and showed an amazing aptitude for languages— by the age of ten she could speak French, Italian and a little Russian—he was proud, too. He wanted her to be smart. But he never dreamed of her being an opera star. He didn't even approve when she began doing radio commercials and programs as a child. Was the dream of her being an opera singer her mother's?

"No, the dream was mine. My mother wasn't a stage mother. But she gave us the dream that we could be anything we wanted, that nothing was out of our reach and that she was there to help us achieve whatever the dream was. And that's exactly how it turned out—we all became what we set out to be, and it's all due to her. My mother is without question the most dominating force in my life."

The discipline from her father, the dream from her mother— perhaps the perfect combination for the making of success. Yet, probably none of it would have come to anything if Sills herself hadn't had an extraordinary drive and an extraordinary gift—her voice. When did she realize that she had such a talent?

"I knew later, not right away. When I was three, I was having such a good time singing and tap dancing and going on the radio and

my Mama making me pretty dresses—it was just a lot of fun. It was really much later, when I began to listen to my mother's collection of recordings, that I got terribly enthralled with the sound of a trained human voice.

"My mother took me to my first opera when I was eight, and I was hooked. I thought it was the most beautiful thing I'd ever heard and I only knew that I wanted to sing like that and be on that stage. And when I told my mother, she hadn't the slightest idea how to begin. She was only giving me singing and tap dancing and piano lessons because she thought all little girls should do those things. What do you do with a child of eight with such an ambition? If you discuss it with anyone, they look at the child as if she's some sort of monster. And I wasn't. I was just a nice little kid who wanted to be an opera singer!

"When I began to push to learn opera, my mother found me a teacher, Miss Liebling. It turned out to be so expensive my father just couldn't afford it—singing lessons were for daughters of very rich people. So I helped pay for it by doing radio commercials and, later, I sang in an after-hours club for tips. But Miss Liebling became terribly interested in me and let my father pay what he could. In a sense, she was my patron, which was very unusual in those days.

"But I didn't really become engrossed with my own voice 'til I was about 12. I couldn't get over what I could do! Suddenly I was hearing it and it wasn't a baby voice anymore. I put on my mother's Galli-Curci and Lily Pons recordings and found that I could do all the scales and fancy things they were doing! I thought, 'I can do what they can do!' I didn't realize what quality meant yet. As far as I was concerned, if they could turn three somersaults, I could, too. The fact that I finished up landing on my behind and they were landing standing up and looking like ballerinas didn't enter my mind!"

But her gift for singing was not all she had. She was also able to learn an entire operatic role in three or four days—another remarkable talent. And she could devote herself to work in a way that very few children that age ever can.

"My life literally changed when I was about 10 or 11 because I dropped my friends. I was so hooked on this art form that I spent all my time in the library, looking up operas, the lives of composers." Impatient with her inability to read operas in Italian, she paid a man in the neighborhood 50 cents an hour to teach her. "Reading just opened up a whole new world to me, and I was ready to move."

When she was 12, Sills's parents put a stop to her life in "showbiz" because they wanted her to have a more normal existence. She

did—she was popular in school, did well in her studies, and had a boyfriend—but she still devoted her every spare minute to music, singing and learning operas. She also kept auditioning for operatic and even chorus girl parts, and she got almost everything she tried out for. But, until she was 15, her father wouldn't hear of her going on stage. "First you go to college, then try the stage," he insisted. Finally, however, when she got a chance to tour Europe singing in a Gilbert and Sullivan repertory, he gave in. To make up to him, she won a mathematics scholarship to Fairleigh Dickinson College before she left.

Sills was never to take advantage of that scholarship or to go to college, for her career quickly took off. By the time she was 19, she was an opera singer. Looking back now, how much does she think her success was due to her talent and how much to sheer hard work?

"Well, I think having a singing voice is a unique talent. It's kind of like a diamond. You can't manufacture a diamond—if you do, it's a fake. But, it does have to be polished and put in its proper setting in order to be appreciated. In the case of a creative talent such as singing or painting, I think quite a lot is God-given. Then it is honed and polished on earth.

"But opera is a highly disciplined art form. You have to know at least two languages, you have to be a musician. It's a lifetime of study and discipline, not just an overnight thing."

Many people don't realize this. Movies and gossip magazines habitually depict opera stars as leading glamorous and fast lives.

"Forget all that—it's all a joke!" Sills exclaims with a laugh. "You can't sing with a hangover, you can't sing with a sore throat from a lot of smoking. You can't sing if you're tired because breath control is the key to all singing, and you get winded. It's a very athletic art form, and you have to be fit. It's not an art form that goes on in spite of the way you feel either, it goes on *because* of the way you feel. Yelling at football games is not for a singer. Nor is yelling at the children! My children were blessed because I was so aware of those vocal chords that they never heard me raise my voice!"

Sills laughs her merry laugh, and leans back against the couch. Cool and unruffled in a plain white summer dress, she nevertheless looks weary. Her lifetime of discipline is apparent in her controlled demeanor, and her 50-odd years of singing can be heard in the huskiness of her voice.

With a life that has always been and still is so busy, it is hard for Sills to find the time to relax. She tries to take six weeks off a year

now, although the opera's schedule never allows her to take the time all at once, and during the season she never gets a Sunday off because there are always two performances that day. Her favorite relaxation is doing jigsaw puzzles, playing word games with her husband, and playing bridge with friends. But getting adequate time to spend with her family has never been easy, and she has a lot of family—three stepdaughters, her own two children and now grandchildren as well.

"The question is always put to me, 'How did you manage to have it all—career and family?'" she says, a little sadly. "Well, I didn't have it all. When you go for all, somebody pays the price. In my case, I think my daughter Muffy paid the price because I was away so much. I kept her with me a lot—by the time she was five, she'd been around the world three times—but I think growing up was a challenge for her.

"Still, there was one mistake I didn't make. I always let my husband and children know that if at any time they wanted me to stop what I was doing, I would stop. They never asked me to, so I guess I was lucky."

Sometimes, though, there were difficult clashes between family and career demands. With a mixture of amusement and regret, Sills describes two such occasions.

"Once, when I was ready to go out to sing a performance of *The Magic Flute*, I went to say goodbye to one of my daughters, who was miserable with a fever and a cold. I was all dressed up because there was going to be a little opening-night party in the theatre afterwards. I leaned down, she put her arms around me, I picked her up out of bed, and she proceeded to throw up all over me!" Sills grimaces, a trace of displeasure on her face.

"So I cleaned us both up, put on a pair of old pants and a shirt and went down to the theatre and sang. I never went to the party." Sills pauses, thinks for a moment, then shrugs. "There are moments when you just can't imagine how you get your act together to go on.

"I was once so tired from having stayed up all night with the children—three of them had measles and it was like a little hospital ward at home—that, after I did my first aria, I walked off the stage into the dressing room door and gave myself a black eye. I was too tired to realize the door was half open. In between that aria and the next there is about a 30-minute lapse—this was also *The Magic Flute*—and people ran with ice cubes and everything. The second aria is very hard, and I did it very badly. Sometimes, it is just impossible."

Sills's problems as a mother were not only ordinary ones, however. One of her stepdaughters and both her own children have disabilities. Muffy is deaf; one stepdaughter is mentally retarded; and her son, Bucky, is deaf, autistic, epileptic and mentally retarded. She found out about her son's handicaps when he was a baby, only two months after receiving the stunning news that her daughter was deaf. Yet, even in the face of these tragedies—and perhaps partly because of them—she has held onto her refusal to be defeated.

"I've always found that at the very pit, and I've been to the pit a lot, there's something that pulls you back up," she says intensely, the sad lines showing again. "I don't know if we're all assigned a little guardian angel or what, but I believe you can only be defeated by yourself, and I don't believe in self-defeat. They told me Bucky would never feed himself—he feeds himself. They told me he would never be toilet trained—he's toilet trained. And he's 23 years old, so don't think *that* wouldn't have been catastrophic. They said that the drugs to control his epilepsy were in their infancy and wouldn't work well. This was 21 years ago, and today they're not in their infancy and he is controlled. His autism—we're reaching him. He's been taught six signs that they use for the deaf, so he's finally communicating.

"And if I've given my daughter nothing else, I've given her [the belief] that she isn't going to be licked either. She's a crackerjack athlete because when she started saying, 'I can't do this 'cause I can't hear the commands, I can't do that 'cause I can't hear what my teammates are doing'—I said, 'Your prowess, your capabilities have nothing to do with other people.' So she has to be twice as alert as the next guy, so what? They said it would take her years to learn to speak—she speaks. She said, how could she be an artist? Now she's designing comic books. She designs *Superman* and *Batman* and other comics, and she's very good at it. She wanted to travel but was worried about traveling alone. I said fine, join a group. I don't accept from her, 'I can't, I can't.' I don't believe in handicaps!"

Because of the problems her children have, Sills became the National Chairman of the Mothers' March on Birth Defects for the March of Dimes in 1972. She helped to raise $70 million within ten years and, unlike many celebrities, she hasn't just lent her name, she's really worked. She visits hospitals, meets the parents of birth-defected children, fundraises and spends time with the children themselves. In her autobiography, *Bubbles*, there is a photograph of her that acutely expresses her sadness. She is half turned toward the camera, reaching down toward a child in a wheelchair, her eyes fixed on him. Her brow is furrowed and the lines that encircle her cheeks are deeper than ever. In that picture, she is not a star—there is no thought for herself or her looks. She quite plainly just hurts.

Yet, she has enjoyed the work, and says that if she had chosen a career other than singing, it probably would have been in the social services, an avocation that is evident in the work she does do. She has, for example, initiated a program to bring opera to disadvantaged children in their own environments. She sends out busloads of singers with costumes and props to schools, where they perform a 45-minute excerpt from an opera. According to Sills, they are reaching about 35,000 children a year now in New York State.

"I don't believe in busing children into Lincoln Center and showing them this glamorous, gorgeous theater that they might never go into again. I believe in bringing it to them in their ambiance so that it becomes part of their everyday life. I'd like them to know that every week, somebody's going to come and tell them a story and sing to them a little bit. I don't care if they become opera lovers or rock lovers, it's just that music should be an integral part of their lives."

She has also worked to make the New York City Opera available to people who like it, regardless of how poor they are.

"People think, 'Opera—big, fat ladies with horns coming out of their heads'—that's dead and buried," she says vehemently. "Opera is not just for the rich lady who has lots of pearls around her neck."

Opera was originally a popular, family entertainment, and in most of Italy, it still is. Opera companies tour the country and perform in large theatres for low prices. People come with food and wine and, instead of acting hushed and reverent like American audiences, they cheer the heroes, boo the villains and throw flowers at the heroines. Grown men cry at the tragedies and everyone jumps up and down and yells at the end. Sills wants to revive this spirit in the New York City Opera, so she sells tickets for $5.50 and up, instead of the $75 it can cost at the Metropolitan; sometimes special performances sell for even less. She has seats in the Standing Room Only sections, so that no one has to be uncomfortable, and Sills is constantly seeking out corporations willing to underwrite tickets to make them even cheaper. In a truly revolutionary move, she has even hung a screen above the stage on which the words of the opera are translated into English, so that everyone can follow the story. Her view is that people should be able to enjoy opera, regardless of how they are dressed or how much they know about music.

"My only requirement for people who come into the theatre is that they come with the idea that they would like to have a good time!"

The innovations Sills has introduced have brought criticism as well as praise. Indeed, throughout her life she has been more subject than most to the opinions of others, because she has so long been in the public eye. How does she cope with criticism?

"Well, it all starts with self-belief. You simply have to believe that you are good at what you do and that what you do is special. I think each one of us is special, otherwise God would have made us all alike. Isn't it interesting that there are no two voices that are exactly alike?

"When I sang a good performance, it didn't matter what was said about it. You could not take that performance away from me. On the other hand, if I gave a bad performance, and I read the next day that it was good, it was still bad. You couldn't take that away from me either, or the ache in my heart from knowing that I had done a second-rate job. But I just don't accept other people putting the stamp of defeat on me. They don't have a right to do that. Only I do. And I just don't punish myself by agreeing with people who don't like me!"

She sits back, the determined, triumphant note in her voice still echoing in the room. She seems to be catching her breath, for she has been speaking fast and passionately.

"I don't think my opinion is worth less than anybody else's," she continues. "I don't know anybody who's in that superior a position to me. There's nobody on earth! I came on earth with as much as they've got." She smiles again, then says almost ferociously, "In whatever I do, I do as best I can, and I don't owe anybody any more!"

Ellen Stewart

Ellen Stewart:
Founding Mother of La MaMa

by Jacqueline Paris-Chitanvis

> *This [La MaMa Experimental Theatre] is the place you can come and hear Swahili, Arabic, Hebrew—name any language, and you'll hear it here. Fifty-five countries have come here to play in my theatre. We're not bound to English at all. Plays are performed in the language of the playwrights. We extend our hands around the world. The purpose is to find ways by which to express theatre on the stage that would communicate with a universal audience. Although dialogue is used, of course, the production is not dependent upon it.*
>
> — Ellen Stewart, 1984

In the world of Broadway theatre there are many names that bring instant recognition—Helen Hayes, Laurence Olivier, Bob Fosse, David Merrick, Joseph Papp. But to the off-off-Broadway theatre goer, no name is more familiar than that of Ellen Stewart, founder and guiding force of the internationally known La MaMa Experimental Theatre Club. In fact, many people see Stewart and her anything-goes experimental showcase as one and the same. And in many ways they are.

An energetic and hard-driving woman, Stewart ("Mama" to her friends) is as outspoken and enthusiastic about the La MaMa theatre as she is closed-mouthed about her personal life. While she will talk at length about her theatre, she adamantly refuses to discuss those aspects of her life that she deems private—her age, family background, personal relationships. (She does reveal, however, that she has a son and a grandchild.) But despite her reticence, a lot can be learned about Stewart by looking at the career path that brought her to La MaMa. It began when she arrived in New York from Chicago in May 1950.

"Like a Cinderella story, by August 1950 I was one of the executive designers at Saks Fifth Avenue," says Stewart. "I remained there until 1958. This set a precedent because there was no such thing as a 'colored'—as we were called—designer at that time. I think I was the first in New York. When I say one of the executive designers, I do mean that. I was not an auxiliary, I was not an assistant. I worked for Edith Lancers at Saks Fifth Avenue, and we made everything from beachwear to ball gowns.

"I learned to sew [as a child] because I didn't like the clothing that my mother made for us," explains Stewart. "In Chicago many of my mother's friends worked for private families. The people for whom they worked would give my mama clothes and she would take those clothes and remake them for us, but I didn't like them. So when I was 12, I started making my own clothes. I didn't know how, but I made them anyway." When she left Chicago, Stewart came to New York to

work and to study fashion because "'colored' were not allowed to go to [fashion design] school in Chicago."

Not knowing anyone when she arrived in New York, Stewart learned her way around the city by riding the subway on Sundays. She would randomly pick a stop, get off and just walk around. "I caught the subway one Sunday, got off at Delancey Street, and I was in the heart of this place where all this stuff was in the streets," she recalls. "Well, I was looking at materials and things when a little man came out of a shop—a tiny little man. He had this black thing on his head. I didn't know that was a yarmulke because then I didn't know what a yarmulke was. He took me in the store to try and sell me something, but I didn't have any money. It was like instant love. In the store were his wife, his sons and his daughters, and that Sunday I became one of his daughters, too. Every Sunday after that I would go and sit in the store with this person I called my Papa Diamond."

Each Sunday evening as Stewart was leaving her Papa Diamond's shop, he would give her a package containing a nice piece of cloth for her to sew. "I would make something and wear it back the next Sunday to show him what I made, because he knew about my aspirations to be a designer."

During this time, Stewart had gotten a job working at Saks Fifth Avenue as a porter. "There all the 'colored' had to wear a blue smock—why we did, I don't know. My job was to be with Edith Lancers who hired me three or four days after I got here. I was to cut the threads from the custom-made clothes that she made, which were brassieres and corsets. I also ran errands and went to get coffee for the ladies who had come there for fittings. However, at lunchtime you could take your smock off and go to lunch. And when I would take my smock off and go through the store, many times I had on the things that I had made. Somehow a legend grew very quickly that I was a model from France wearing Balenciaga clothing! Some of the customers in the store who would see me on my way to lunch would demand to know where I got what I was wearing. I would tell them it was mine, and they would be very mad and say that it wasn't mine, it had to be the store's. So rumors flew that Saks Fifth Avenue had a promotion going. I was the mysterious model. I was this, I was that, but I wasn't *anything*."

One day a customer decided that she wanted to buy what Stewart had on. According to Stewart, the woman went to the personnel office and, declaring that she was a big charge account customer, demanded to purchase the item the model was wearing. The people in personnel explained that there was no such person and went with the customer throughout the store looking for the mysterious model.

They soon found Stewart in her blue smock and the matter was dropped. But after a few more customers inquired about the clothes she wore, Edith Lancers went to the store's owner, at the time Sophie Gimbel, and asked her if Stewart could work as a designer's apprentice. Gimbel refused. "But women still wanted to buy whatever they saw me with," says Stewart. Soon she got her big chance.

"On one occasion I fixed a dress for one of Edith Lancers' customers while she was away on vacation. The lady liked it, and she ordered a lot more things. And when Edith returned they [others on her staff] told her." A few weeks later, Stewart was marched up to the mezzanine floor and given her own work space with 15 sewing machines and a cutting table. She also was informed that from that day on she would be called Miss Ellen. The use of a title with her name was an unprecedented show of respect at the store, according to Stewart. "Blacks," she says, "had to call all whites Miss, but no 'colored' were allowed to be called Miss. But Edith told me that from that day on I could take off the blue smock and I was to be called Miss. I was to be her executive designer, and we were going to make these custom-made clothes."

Stewart still remembers how scared she was. "The only way I knew how to sew was on the floor. I didn't know how to cut on the cutting table. I didn't know how to make a pattern," she says. Despite her initial fears, she was a hit. Customers constantly came in to order her clothes. But all was not happiness during this period.

Other Blacks who worked at Saks also wanted to be treated with the respect accorded Stewart. They put together a petition asking that they no longer be required to wear the blue smocks and that they also be addressed as Miss . Stewart was approached to submit the petition, and she agreed. Not unexpectedly, the requests were denied. But to Stewart's chagrin, she was snubbed by her fellow Black workers—they wouldn't speak to her or eat at the same lunch table—because she continued to enjoy privileges that were denied them.

"The most prestigious job you [a Black] could have at Saks during that time was to run the elevators. Well, when I would go to get on the elevator they would close the door in my face. This was going to go on until I demanded to wear a smock or refused to be called Miss. The pressure was so heavy that I quit the job."

It was her friend Papa Diamond who convinced her to return. "He talked to me and he said that although it was hurting, if I succeeded that some time or other it would be like a pathway for other Blacks to be designers. He got me to go back." Although she continued to get the cold shoulder from most of the other Blacks at Saks, Stewart stayed with the store until 1958.

Later in her design career she did free-lance work for Henri Bendel, Bergdorf Goodman and other leading stores. "One of the things I am very proud of is that when Queen Elizabeth II was being coronated, several Americans were invited to the ball. I dressed two women for that ball and was the only American [designer] who had two gowns at the coronation." Stewart also is proud that she was once invited to Paris by Christian Dior to work as one of his junior assistants—the only American that he asked.

"The struggle that I had was on a personal level with people," she says. "A struggle to be successful, I didn't have."

After an illness, Stewart stopped working full-time and did only free-lancing. "I would work only enough to do what I wanted," she says. She wanted to go to Morocco, and off she flew one day to the Casbah. One night she met an old friend and went up to her room to talk. "I was feeling sorry for myself, being ill and worried. But while I was talking to her it was as though my Papa Diamond spoke," she says. "He was the first person to put a pushcart on what is now Orchard Street. He came [to the U.S.] when he was 12 years old from Rumania, and he had a little pushcart [from which he sold his clothing goods]. He used to tell me, 'You get a pushcart and you push it. Push it for other people and it will take you where you want to go.' So while I was in this room with my friend Theresa he spoke to me. And I left Morocco the next day to come back to New York and to get myself a pushcart."

Back in New York, Stewart decided that her "pushcart" was going to be a theatre for her foster brother (whose play had been ruined by Broadway producers, leaving him devastated) and for her very close friend, Paul Foster, who was an aspiring playwright. (She thought the theatre would encourage her brother to write again, but he never did.) Her plan was to set up a boutique from which she would make clothing to be sold to shops on Madison Avenue. With this money she would run a theatre at night. "I had one room that was going to be the sewing space and one room that was going to be the theatre."

Because she knew she would have no problems selling her designs, Stewart initially thought that setting up the theatre would also be a cinch. But that was not the case. "In 1961, there existed in New York a law called the landlord's covenant, which meant that [the owners of] any three buildings in an area that were side by side could sign an agreement... that no Jew, no Hispanic and no 'colored' could live in those buildings," says Stewart. "And this could be legally enforced. I had our first place in the basement of one of these 'covenanted' buildings—I didn't know anything about that at

the time. The people living in the building did not want to live with a 'nigger' in the basement. So they tried to enforce this law to get me evicted. However, the building had changed hands and another person had bought it. He was from the Ukraine, and he told me that he was from a land of persecution, and that he was not going to persecute me. He invited everyone in the building to move out, but said that I was going to stay."

Still, her troubles didn't end. "One day a man came down to this little place that we were fixing up, and he had a summons. He had been called by the people in the building saying that a Negress had entertained 16 white men in five hours and they wanted this stopped. Now what had happened was that I knew many, many white models and there was Jim [Moore, her business manager] and his friends who were white and there was Paul Foster and his friends who were white. My brother was not participating, so all the men who were helping me install this or that *were* white men. They would come in and out, and people *did* see these men coming and going." Fortunately, the man who came to serve the summons had worked in vaudeville. And after Stewart explained what was going on, his heart was with the group. He suggested that they get a restaurant license (all they needed to do was to serve coffee) and become a coffee house to prevent further problems with the law. Volunteering to get the license for them, the man wanted to know what name they would use. "The kids all called me mama, even then," says Stewart, "and when he asked what the name was going to be, one of the kids said, 'Mama, what's going to be the name?' So he wrote down Mama, and then another friend said, 'Call it La Mama.' We got the restaurant license and that's how we began."

The harassment from the neighbors continued—parts of the building were vandalized, garbage was dumped in her entrance way—and eventually Stewart moved La MaMa to a building on Second Avenue. But her troubles were not over yet. On several occasions she was arrested and went to jail for operating a theatre without a license. "It was impossible to get a license," she recalls. The good that came out of having to move the theatre from place to place was the direct influence it had on La MaMa's growth, according to Stewart. "Each place that we moved to happened to be larger than the previous place," she says. "Therefore, the people who were working had to write plays that were 'larger' to fit the new large space. That's how we really grew."

Another thing that influenced the free-style content of the productions at La MaMa was Stewart's loathing of soap operas. "My mother used to rent rooms in her house to supplement the income, and we didn't have a room for ourselves," she says. "We slept in the

dining room on a couch that had to be folded up. She liked her soap operas—she listened to them on two radios. When you were at home you listened whether you liked to or not. And I hated them. So that anything that smacked of a soap opera I didn't like. Some of the plays in the very, very beginning were similar to soap operas, but as much as I could, I pulled away from that sort of thing and moved more into things that had music and movement."

In 1965, Stewart and members of her theatre company went to Europe with 22 plays to perform and be reviewed. "The [New York] critics refused to come to see our plays, and I thought that many of the plays that I had should be pushed," she explains. "We were the first American troupe to take plays to Europe and to play in the festivals, and we have been doing it ever since." Not limiting herself to performing in Europe or the United States, Stewart travels extensively throughout the world. She has been to numerous countries, from the Far East to Africa to the Middle East to South America. And despite her notorious bouts with air sickness ("I'm stick as a dog all the way there") she loves to visit other countries.

Now 23 years after she started her theatre, Stewart doesn't have to worry about getting her plays reviewed, nor does she worry about her location. Since 1968, La MaMa has made its home at 74A East Fourth Street on Manhattan's lower East Side. Her theatre companies (she has had an assortment of troupes ranging in ethnicity from Native American to Asian-American to Afro-American), and their innovative works have performed across the country and throughout the world. La MaMa also has hosted many international troupes here in the U.S. The list of playwrights whose works have appeared at La MaMa is massive. It includes many playwrights who were unknown at the time but who since have become award winners: Harold Pinter, Lanford Wilson, Tom Shephard, Ed Bullins and Megan Terry. In addition, many of the people who have worked at La MaMa were equally talented: Bette Midler, Jill Clayburgh, Danny DeVito, Nick Nolte, and directors Tom O'Horgan, Andrei Serban and Jerzy Grotowski.

In recognition of her contributions to the theatre, Stewart has received numerous awards and citations, including the Vernon Rice Award for outstanding achievement in the off-Broadway theatre, the New York State Award from the New York State Council on the Arts and a *Village Voice* Obie Award (a special citation for La MaMa's 20th anniversary celebration). She also has been presented with several honorary degrees.

But despite Stewart's reputation and the theatre's artistic triumphs, La MaMa is not a financial success and never was intended to

be. It subsists on funding through grants and money brought in by ticket sales and is much as it was in the earlier years. Stewart, who has been at the helm of the theatre since 1961, only recently decided to share her responsibilities. In May of 1984, Wickham Boyle, a 33-year-old Yale graduate, joined La MaMa as its first executive director. Stewart says she hired the younger woman because she needed someone to help her that she could trust — someone who didn't mind doing many of the things that she does around the theatre, such as cleaning the toilets. Among Boyle's more official duties is the writing of grant proposals to bring in more funding.

Are there other changes in La MaMa's future, say, a move to a classier neighborhood or a change in the theatre's format? A move seems highly unlikely. Stewart says she likes where she is. To her the lower East Side, with its mixture of people and unpretentious air, *is* New York. As for changes in the theatre's focus, that, too, seems unlikely. "La MaMa is for me the same little coffee house," says Stewart, "and it is open to all people."

Geraldine Stutz

Geraldine Stutz:
She Minds the Store

Barbara Bersell

by Roslyn Lacks

Fashion is a reflection of what is going on in the world. The wider your horizons, the more intense your curiosity, the more extensive your range of reading, the better equipped you are for a job in the world of fashion. You need the kind of sophistication that is synonymous with knowledge about the world.

After that, you must be willing to work very hard. It's not a nine-to-five business... I know no one involved in fashion design, retailing or promotion who works less than ten hours a day, in many cases, six days a week. Fashion means "of the minute." Unless you keep moving from minute to minute—that is, from season to season and year to year—you are no longer equipped to be in the mainstream of fashion.

—*Geraldine Stutz, 1984*

Its small, narrow facade wedged between brick giants that loom over it, Henri Bendel is unique, even on fashionable West 57th Street. The store reflects the taste and temperament of Geraldine Stutz, the woman who was chosen to head it in 1957, when she was only 33 years old. Today, she owns the store she minds. Backed by a Swiss-based investment group, Geraldine Stutz made headlines in 1980, when she bought the store from Genesco, the corporation that owned it. She remains a distinctly individual entrepreneur in an era marked by increasingly large conglomerate takeovers.

Small boutiques line Bendel's first floor, each a specialty shop offering what Stutz calls "the ornaments of living," from the crunchiest croissants to the most exquisite perfumes, all distinctively selected and displayed. Today, the concept of the boutique—Bendel's trademark—is emulated everywhere. Yet when Stutz introduced her Street of Shops in 1959, merchants laughed, dubbing it "The Street of Flops" or "Gerry's Folly."

Born in the midwest and educated in convent schools, Stutz majored in drama and journalism at Chicago's Mundelein College, where she graduated with honors. After college, she worked as assistant to the Director of Chicago's Fashion Industries. A job as fashion editor for a series of movie magazines brought her to New York in 1949. The following year, she joined Conde Nast Publications as fashion editor for *Glamour* magazine. In 1954, she moved from editorial work to fashion merchandising, becoming fashion coordinator for I. Miller, which was then a division of the Genesco Corporation. Here, she caught the attention of H. Maxey Jarman, Genesco's founder and chairman, who subsequently appointed Stutz vice president and general manager of I. Miller's retail shoe stores.

Indeed Stutz generously credits Jarman with the kind of insight and outlook, unusual in his time, that made it possible for her to move up the ladder of fashion merchandising as rapidly as she did.

"Maxey made a singular statement in the '50s," Stutz observes. "Fashion is probably the biggest single field directed toward women. Jarman suggested that a business directed to women might better be run by women than by anyone else. I've never heard any other tycoon or entrepreneur or any bigwig in this business say that since."

When Genesco bought Bendel's in 1957, the store was a staid white elephant in serious financial trouble—losing about $1 million annually on sales of $3.5 million. Stutz asked for five years to try to turn the store around when Jarman proposed that she take it over. A radical revision of its merchandise and appearance ensued.

"Since I didn't know any better and was not a professional merchant," explains Stutz, who was later dubbed "The Merchant Princess" by *Fortune* magazine, "what I did was to narrow the store's focus to a single customer on the theory that given our size, it was better to try to be everything to one specific customer than to try to be a little bit of something for every customer."

The customer to whom Bendel's would address itself might range in age "from eight to eighty" but was clearly defined by a small-boned elegance of style and size. (Bendel's carries no sizes larger than ten.) Indeed, the Bendel woman is very much like Stutz herself, who at 5 ft. 4 in., slips easily into a size 6.

"We're not mass merchandisers," Stutz emphasizes. "We edit our collections. We don't offer the whole world. People come to us because they like our editing; we've saved them, they realize, a lot of trouble."

After working out Bendel's new approach in 1958, Stutz began the search for a "talking dog" to convey that approach to the public.

"It seemed to me," she explains, "that we should have a projection of what we were about. A talking dog is something you put outside a carnival to bring people in. We needed something that would announce to the world that new things were happening at Henri Bendel."

She called on H. McKim Glazebrook, then a young designer with the store, to come up with plans for a revamped first floor, one that would provide it with a sense of intimacy.

"A Gothic bowling alley," is how Stutz describes the long, narrow, high-ceilinged structure they sought to transform.

Glazebrook came back with a design for the Street of Shops, reiminiscent of his childhood in Palm Beach.

"A bazaar image," is how Stutz views it, "dating back to the souks [markets with stalls of merchandise common to the Middle East and North Africa] of Mesopotamia, but not seen in the northeast sector of this country in decades."

She took to Glazebrook's idea at once, and they put the plan into effect, revolutionizing the fashion industry. The boutique motif was echoed in designers' collections on each of Bendel's floors.

Now that it has been emulated by the very merchants who derided it when she first introduced the concept, Geraldine Stutz estimates that it's time to move on: Bendel's third and fourth floors are currently being transformed once more—this time, into large connecting loft spaces.

"It's a matter of first in, first out," comments Stutz. "When you're the precursor of a trend that you begin to see everywhere, it's time to move on. We should be on the wave of a cleaner concept of shopping for women who are more knowledgeable today than they were 25 years ago.

"Women have come a long way since the days designers were first introduced," she observes. "Then, you really needed to separate one designer from another, so that the character of each could be seen. Today, women don't want to pile through everybody's sweaters separately; they simply want to see the sweaters. We've opened the floors so that all the sweaters are in one place, the skirts in another. We're entering an era in which women are much more prone to want what suits their lives, rather than what they are told by a combination of the fashion press, merchants, and fashion designers. It's a much more straightforward way of presenting merchandise; it's 'show' rather than 'tell,' and I think it's right for the times."

The street floor of shops that so distinguishes Bendel's, however, will remain. "Here," Stutz points out, "the shops were never set up on the basis of individual designers, but rather on categories of merchandise." Although those categories may have changed over the years, the floor remains structurally exactly as it was when Glazebrook designed it 25 years ago. "The shops function marvelously," Stutz notes. "They seem to be just the right size. McKim Glazebrook was a great designer."

Stutz's eye for talent is legendary. She picked a young unknown named Andy Warhol to do her first store ads. (Stutz met Warhol when he was drawing shoes for I. Miller.) Early in her career at Bendel's, she introduced the phenomenon of the Friday morning

fashion audition. Her credo: "If you can't afford to hire the best, you hire the young who will become the best."

To this day, young designers present their work to the store's buyers on Friday mornings. Stutz estimates that 20% of Bendel's merchandise comes from the Friday line-up. Some of today's best-known designers got their start at Bendel's, among them Sonia Rykiel, Jean Muir, Mary McFadden, and Stephen Burrows.

Driving down the East River Drive on her way to City Hall to meet with the other women who are profiled in this book, Stutz looked out at the waters of the East River and was reminded of her own first day in New York. She had been staying with a cousin in New Jersey who deposited her on Madison Avenue at the offices of the motion picture magazine where she was to begin work.

"I went upstairs," Stutz recalls, "got my first assignment and came out into the street, having no notion of where I was or how to maneuver. I then had an inspiration. I thought of the East River as Lake Michigan and simply worked my way west to Seventh Avenue."

Soon enough, the city became home for the talented young woman from Chicago; she has never considered living anywhere else.

"I come from an era in which kids grew up with a picture of New York totally drawn from the movies," says Stutz. "Most movies of the '40s were set in New York. All the comedies and melodramas were about life in the city. So one knew what it looked like. I'll never forget being taken to a party on Beekman Place shortly after I arrived," she says, smiling at the memory. "I walked into this slick New York apartment and looked out over the river with the Coca-Cola sign and the 59th Street bridge. It was one of those 'Manhattan, you are mine' views!" Her smile edges into light laughter. "New York in those days was very like the movie version of it," she declares. "I felt immediately at home."

While the city and Stutz merged with ease, her first job presented problems. Different from anything she had tackled before, it entailed tasks that were beyond her background and experience. At a loss, she called on Mary Campbell, personnel director at Conde Nast publications. Campbell had taken an interest in Stutz's career when, as a senior in college, Stutz entered Conde Nast's Prix de Paris contest. She did not win, Stutz points out immediately, but placed among the contest's first 25 entries and evoked the company's interest.

"My entries were always late," says Stutz ruefully. "My reasons for their tardiness," she adds wryly, "were absolutely fascinating."

Nonetheless, Conde Nast felt Stutz was a young woman worth watching, and it was to Mary Campbell that she turned for advice in the midst of her insecurities at her first job, advice that Stutz remembers to this day.

"You can do one of three things," said Campbell to Stutz. "You can go home to your mother, which is what you feel like doing—don't do it! Or you can try growing up and standing on your own two feet. Second, you can come here and take a job that's below your skills and experience, but I don't think that's your style. The third thing," suggested Campbell, "is to stick with the job you have because you're working with a professional organization where you will learn. That means learning everything there is to be learned in whatever spot you are. And that will stand you better in the long run than anything else."

The nub of that philosophy stood Stutz in good stead and is echoed in how she advises others today. "Don't move from a job until you have learned," she pauses before each word for emphasis, *"everything there is to learn.* When there is no more to learn," she concludes rapidly, "go."

And "go" is very much the word for Geraldine Stutz. "You never stop," is how she puts it. In addition to maintaining her lead in New York's fast-paced, competitive fashion world, with all its grit and glitter, Stutz manages, in her own words "to move in 12 directions at the same time. She is a member of the National Council of the Arts, serves on the Board of Directors of the Fifth Avenue Association, on committees for the city's leading theatres and museums, as well as on the board of directors of a half-way house for drug addicts. She spent the day following her purchase of Bendel's shopping for garden plants, part of a ten-year plan for her house and property in Connecticut that is no less ambitious than her revamping of the store. In the midst of all this, she has been elected to the Best Dressed Hall of Fame and received the Best Coiffed American Woman award. What enables her to manage it all?

"The constitution of an ox," replies the delicately boned Stutz. "It's the most important requirement for doing a lot of things. Clearly, I've inherited an enormously good constitution and I value it, so I take good care of myself—getting enough sleep, eating the right kinds of food, exercising. What you need most to make your mark in any field of endeavor," she suggests, "is the gift and blessing of good health. It's very hard, otherwise.

"My mother was a woman of enormous energy," Stutz adds, "and so is my sister."

Stutz's mother managed a department for Du Pont in Chicago. Her sister, Carol Hopkins, directs a program for remedial teachers at Chicago's Loyola Academy. Alex Stutz, her father, was a contractor who decided to retire at the age of 50.

"I don't think energy was his long suit," observes Stutz.

Despite their capacity for work, both her mother and younger sister followed a pattern that prevailed in their time and place, one setting marriage and career in opposition to each other.

"My mother was one of those rarities in the twenties," remarks Stutz. "She was an upwardly mobile corporate person. For a woman in those days, it was an extraordinary feat. Yet she did what most women did then. When she married, she left work and did not return until 18 years later whan she and my father separated."

"My sister," Stutz notes, "did approximately the same thing." Her sister taught briefly, gave it up when she married some 30 years ago, and proceeded to have seven children in as many years. When her marriage ended in 1971, she returned to college to earn a master's degree in remedial teaching. In 1979, she was voted "teacher of the year."

How did Stutz manage to elude so strongly entrenched a pattern?

"It simply never dawned on me to leave work," she says. "I was one of the few young women in my kind of circumstances—a convent school upbringing—who never thought of entering the convent. I certainly thought, like all young women, I suppose, that I would marry and have children. It seemed something that would happen, but not a priority. Going into the convent or marrying immediately after school was the step taken by most of the young women with whom I grew up, but it never seemed an immediate step to me, not at all."

Today, the tension between marriage and career—the notion of choosing one *or* the other—has diminished. Most young women assume their lives will encompass both.

"There's no question that you can juggle all kinds of things in your life and times," Stutz agrees, "marriage, career, and children, provided," she cautions, "that you are willing to recognize that you can't do them all brilliantly"; she pauses, reflecting on her own experience, "and that you're not expected to."

Stutz was married to British artist David Gibbs for 15 years. Their marriage ended in 1977.

"I was brought up to succeed," Stutz explains, "and that was one of the problems with my marriage—the feeling that I was totally

responsible for its success, and that if any part of it didn't succeed, it was up to me to do something about it. I was also married to a man," she notes with wry chagrin, "who happened to share that philosophy. With that kind of burden," she suggests soberly, "there is no relationship. It's impossible to sustain."

While styles in both marriage and work for women have changed substantially over the years, neither situation is as ideal as one might wish.

"The world of fashion and merchandising for women today, is very much better than it used to be," notes Stutz, "but it's not nearly as good as it ought to be. Women have always been a major work force in fashion merchandising, but have seldom, until recently, been allowed into the upper echelons. Merchandising manager used to be the most a woman could hope for."

In fact, Stutz recently attended an evening that saluted nine women presidents of retail stores—five more than existed when she became president of Bendel's in 1958. "It will continue to get better," she predicts.

How would a young woman today go about training for a career in fashion?

The first step Stutz advocates is a good general education, essential as a base for whatever one wants to do in fashion, whether it's manufacturing, the creation of fashion, merchandising or promotion.

"Fashion," she points out, "is a reflection of what is going on in the world. The wider your horizons, the more intense your curiosity, the more extensive your range of reading, the better equipped you are for a job in the world of fashion.

"After that," she stresses, "you must be willing to work very hard. It's not a nine-to-five business, no matter what area you're in. I know no one involved in fashion design, retailing, or promotion who works less than ten hours a day; in many cases, six days a week. The rewards are that you are constantly growing; you are doing something that uses your eye and gratifies your sense of form and color. Nobody," she adds, "gets into fashion or is even interested, unless those things are important to them."

The creative end of fashion—design—requires both a specialized education, available at fashion institutes in the city, and a period of apprenticeship.

"Hitch yourself, if you can, to the stable of a good designer on Seventh Avenue," Stutz suggests. "Most designers today are big

business. You must pay your dues by working in somebody else's design room before going out on your own."

Careers in both fashion merchandising and promotion begin with on-the-job training. "Go in on any entry-level job," Stutz advises. "Most stores today have good training programs in fashion merchandising. If you're interested in retailing, pick a store you admire, and try to get into their program.

"A good editorial operation provides the best training ground and finishing school for fashion promotion," according to Stutz. "The magazine field is more limited today," she notes, "but it's still the best area for basic training in fashion promotion. Barring that, you might try advertising agencies that handle fashion accounts; but these, too, tend to choose their people from the editorial world."

In the course of her own career, Stutz has travelled all over the world—from Paris to Fiji—in search of fashion. But she remains an unregenerate New Yorker. It is the city to which she always returns; it is clearly the place of her choice.

"I'm as complete a New Yorker as you will find," she asserts with the glimmer of a smile, "which is what all of us who were not born here say."

What does being a complete New Yorker mean to Geraldine Stutz?

Her eyes light up and the smile, for which she is famous, flashes across her face.

"Someone who finds *everything*," she says, underscoring the word, "about this city necessary. All of the discomfort and all of its electricity; all of the competition and all of its riches of people and places, of all the arts and the sights and the sounds. It's a dazzling experience! I think it's the most interesting place in the world."

Chien-Shiung Wu

Chien-Shiung Wu:
A Life of Research

Columbia University

by Jacqueline Paris-Chitanvis

> *Research is a wonderful thing. Whenever students ask if they can do research with me, I always tell them, "You must take it as your life. It is not a job; it is not a career; it is your life. Unless you are really interested, don't do it." When you do research, first, you must really try to understand the problem very clearly, then you try to think how to attack the problem, and if you can attain the same results by attacking the problem in many different ways, it gives you such a satisfying feeling. One of the most important things you must have is perseverance. You must not give up. It is very difficult, but it is wonderful, because you are doing what you like to do best.*
>
> —Chien-Shiung Wu, 1984

In 1957, Columbia University in New York called a press conference to announce that Chien-Shiung Wu, an associate professor in nuclear physics, had completed experiments that unquestionably disproved a basic law of physics, the conservation of parity (simply put, the contention that any atomic or molecular system and its mirror image are symmetric). Disclosure of the results of these experiments had two important outcomes: Nobel prizes were awarded to the two theoretical physicists, Tsung Dao Lee and Chen Ning Yang, who first proposed the theory disputing the conservation of parity law. And a place was secured in scientific history for Chien-Shiung Wu.

Recognized as one of the most gifted members of her profession, Dr. Wu has received numerous honorary degrees and awards for her contributions to physics. Yet few people in her native China would have predicted such a future for her when she was born in Shanghai in 1912.

"You must remember," says Dr. Wu, "that at that time in China very few girls went to school. I was fortunate. My father was a very special man and a great encouragement." He was, she contends, the greatest influence on her life.

A self-taught man, Zong-Yi Wu strongly believed in educating children. To this end, he moved his family from Shanghai to the countryside where he set up a grade school. "My father started the school mainly to encourage girls to go to school," says Dr. Wu, "and my mother used to help him. She would go to the families, talk to the mothers and ask them to send their girls."

Zong-Yi's interest in educating children especially applied to his family. He firmly believed that his daughter had as much ability as her two brothers and he never stopped encouraging her to learn. After completing his grade school, the young Chien-Shiung was sent to Soochow to attend high school. Still later, she enrolled in the National Central University in Nanking [now Nanging] where she received a

bachelor's degree in physics. And when she expressed an interest in going to the United States for graduate work in physics, Zong-Yi again gave his daughter his blessings. "My father was wonderful," says Dr. Wu, with deep respect in her voice.

When her ship docked in San Francisco in 1936, Chien-Shiung Wu's destination was the University of Michigan in Ann Arbor, but she never completed the trip. "A friend of mine who lived in Berkeley met me at the boat," explains Dr. Wu, "and took me over to see the campus [University of California]. There I met someone who told me about another Chinese student who had just come from China and who also was studying physics. Later that afternoon, the student came over to my friend's home and told me everything about the department, the faculty and the courses. He told me to go see the chairman [of the physics department] and I did. And even though school had already started, the chairman let me in."

This change in plans, acknowledges Dr. Wu, made a big difference in her career. "At that time the physics department at Berkeley was in a golden age," she says, citing the many giants of physics who were working there. "[Robert] Oppenheimer [called the "father of the atomic bomb"] was there, [Ernest] Lawrence was there [builder of the cyclotron, an atom smasher]. And many young people from this country came to Berkeley to study. It was fantastic; it was like a mecca. Each year people in physics from all over the world came to visit Berkeley."

Wu, who had Lawrence as her advisor, says she benefited greatly from contact with the many gifted physicists who were on the campus. "I was especially lucky in that I worked very closely with Professor [Emilio] Segre, who later won a Nobel Prize in physics," says Dr. Wu.

In 1940, Chien-Shiung Wu received her doctorate, and in 1942 she married the young physics student, Luke C. I. Yuan, who had been so helpful six years earlier. It seemed, at first, that nothing romantic would develop out of the two students' friendship, because a year after their first meeting Luke transferred to the California Institute of Technology in Pasadena to work with another famous physicist, R. A. Millikan. "We didn't even correspond until after we got our degrees," says Dr. Wu. "Then I was sent from Berkeley [where she was doing postgraduate work] to Los Angeles to do an experiment at an airplane company and he was there."

After marrying, the two young scientists came East to work. He went to work at the RCA Research Laboratories in Princeton, New Jersey, and she went to Smith College in Northampton, Massachusetts, as an assistant professor. Because of their job locations, Dr. Wu and her husband were apart much of their first year of marriage. But it was during this period that New York first took on special meaning for her.

"Once every two weeks, sometimes every three or four, Luke would come from Princeton, and I would come from Northampton. We would meet at Grand Central Station and stay at the Commodore Hotel. Oh, how we loved the Commodore Hotel!" says Dr. Wu. "It was not very easy to get a room in hotels at that time because it was during the war years [World War II] and there were always lots of servicemen in town. But the people at the hotel were very nice and always tried to find a room for us."

After a year, Dr. Wu left Smith College and went to work at Princeton University, becoming the first woman to teach at the then all-male school. That was in 1943. "After a year or so, Columbia University asked me to come to New York," says Dr. Wu. And though the move would again separate her from her husband, Dr. Wu accepted, joining a team of scientists in the Division of War Research who were collaborating on the top-secret Manhattan Project—the atomic bomb. Her invitation to join this select group was based on unpublished research she had done while a student at Berkeley. (This research, which was part of her doctoral thesis, had to do with the gases emitted when the uranium atom was split.) Following the war, she stayed on at Columbia and continued working as a senior research scientist.

In 1947, Dr. Wu gave birth to her only child, Vincent. And while most women during that time stayed home to raise their children, Dr. Wu continued working. "You see, this is what I believe in, especially if you are doing research in a field such as physics. It is the kind of science that keeps on going. You just cannot step aside, because later you cannot catch up. Also, if you are in a school, you have a responsibility to the students, the department and your colleagues.

"When my son was very young, from birth to about two-and-one-half years old, I had someone live in," she says, noting that she was "really lucky. We were living in Princeton—although I had an apartment in New York for the weekdays—and I put an ad in the newspaper for someone to come and look after my newborn baby. One day a lady came whose son was studying for his Ph.D. in mathematics at Princeton. She was very nice and immediately called herself a grandmother. She said to me, 'Mrs. Yuan, you can go back to New York. Don't worry. I will look after Dr. Yuan and the little one.' And she turned out to be a wonderful person."

When her son was almost three, Dr. Wu and her husband moved the family to New York. It was then that the woman who was taking care of Vincent retired and moved to California. Once settled in, Dr. Wu put her son in a nursery school and continued working. She became an associate professor at Columbia in 1952 and a full professor in 1958. That same year, she was elected to the prestigious National Academy of

Sciences. In 1972, she received two new honors. She was appointed Pupin Professor of Physics at Columbia (a professorship named after pioneer physicist Michael I. Pupin), and named to the American Academy of Arts and Sciences. In 1978, she served as president of the American Physical Society. Over the years she has been the recipient of several honorary degrees (including ones from Princeton, Rutgers, Harvard, and Yale) and numerous awards, such as the National Science Medal and the Cyrus B. Comstock Award from the National Academy of Sciences. Although she retired from her professorship at Columbia in 1980, Dr. Wu still maintains an office there and puts in many hours.

Does she think the years of nonstop work negatively affected her family? "No," she replies in a soft but firm voice. The Yuan family—which now includes a daughter-in-law and a six-year-old granddaughter—by all accounts is a close one. Her son even chose the same profession as his parents. A choice, Dr. Wu quickly points out, that neither she nor her husband ever pressured him to make. She says her son is his own person and she likes to demonstrate this by recalling an incident that occurred when he was a young boy.

"My son changed as he was growing up," she says with a smile. "When he was young he was very extroverted and talked a great deal. I remember that we would always say, 'Vincent, let other people talk, let other people talk.' Then one day he comes to me, sits down and says, 'Mommy, I want to be an introvert.' And then he doesn't talk much anymore. He was around ten then and even now he doesn't talk very much."

As for her marriage of 42 years, it is and always has been special, according to Dr. Wu, who says she has no regrets for the way she and her husband have lived their lives. "My husband is very considerate. He is not demanding, and since he also is a physicist, he knows the amount of work that one must do," she says. "For a long time we have come together only during the weekends. He works in Brookhaven [a national laboratory on Long Island] and I'm here in New York. Usually he comes home on Fridays, but sometimes I go out—we have a home there, too. When we are together we enjoy home life, but even on weekends we sometimes have work to do, so we take time out for work."

How does she relax? She reads, experiments in the kitchen with Chinese cooking or just enjoys looking at her fine collection of Chinese art reproductions. Usually, though, she likes to walk around and enjoy her adopted city. "You can feel the vibrations in the air, she says excitedly, "especially when you return from being away. There is nothing like Kennedy Airport. You can feel the energy, the air vibrating."

Dr. Wu especially likes the impression New York gives of being "an assembly of different villages. Here and there different kinds with very different characteristics," she says. "People in New York are very nice, too. But if you don't like them in one area, you can go to another."

And while some people complain about it, Dr. Wu likes the anonymity that a person can have in New York. "People don't pay attention to you. Professors can walk on the street eating an ice cream cone, and nobody pays attention. But in a small town this often can't be done. I remember," she laughs, "one weekend I went home to Princeton. I jumped off the train and got in a taxi and the taxi driver said to me, 'Hey, the lady who worked for you died yesterday.' Now he knew that a lady who used to work for me had died yesterday, and I didn't even know about it or him. Now that was a small place."

But New York has much more to offer than anonymity, according to Dr. Wu. "We have so many wealthy people," she says. "If only they would all do something to remove some of the poverty and to start more interesting activities for young people, such as street dances or music festivals. It would be so nice."

Dr. Wu also thinks that there is a lot that New York's youth can do for themselves. She particularly laments the fact that many of them don't take advantage of the city's fine cultural facilities—museums, libraries, schools, theatres—and subsequently are not exposed to many different things. "Because of this, many young people often don't know what they want to do with their lives," she says. She believes that utilizing the libraries and reading about all kinds of things can help make young people aware of the different opportunities in life. She also thinks that they need to develop better learning habits.

How can they do this? "Work as a scientist," she advises. "Ask the right questions, keep good notes and try to understand things clearly. All of these things—whether you become a scientist or not—are good for any profession."

But being a scientist, Dr. Wu naturally would like to see more young people, especially women, consider a career in science. "I cannot understand people who say girls are not suitable for or not good at science or math," she says. She rejects this notion and notes that many young women also are now refuting it. For instance, when she recently attended an awards celebration in Minnesota (given by the American Academy of Achievement) to which 300 honors students in science and math were invited, she says she did not expect more than half of them to be young women. "I was surprised," she acknowledges, "but so pleased to see all the girls there, and with such complete confidence."

What would she like people to remember most about her? Her numerous awards? Her ground-breaking experiments? "That they could trust and depend on me," she replies.